# GARDENS
### *of the*
# RENAISSANCE

"You should have gardens where you can stroll and, on occasion, host banquets…where you can arrange rare and exotic plants with care. In these places, you can especially appreciate the careful arrangement of myrtle, boxwood, citrus trees, and rosemary… [Gardens] greatly increase the splendor of villa estates."

GIOVANNI PONTANO
*De splendore* (ca. 1494–98)

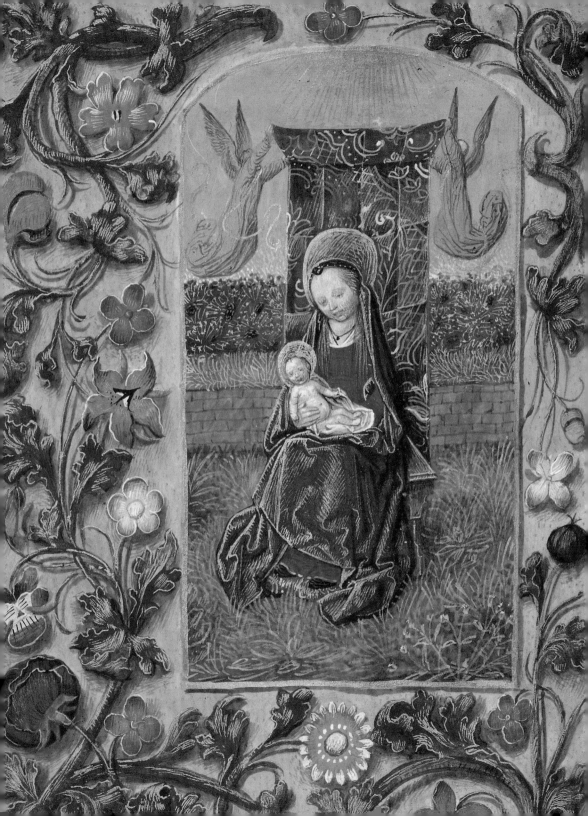

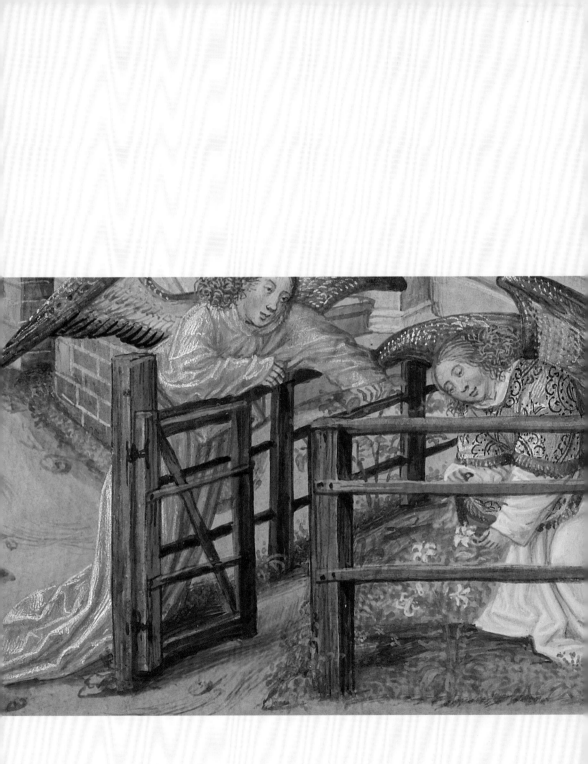

# GARDENS
## *of the*
# RENAISSANCE

BRYAN C. KEENE

The J. Paul Getty Museum, Los Angeles

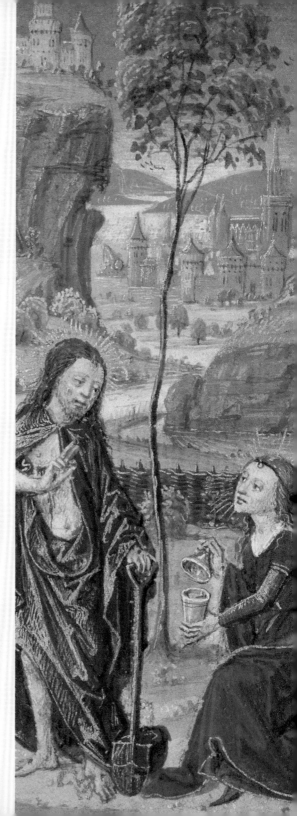

This book is published on the occasion of the exhibition *Gardens of the Renaissance*, on view at the J. Paul Getty Museum at the Getty Center, Los Angeles, from May 28 to August 11, 2013.

**Published by the J. Paul Getty Museum, Los Angeles**
Getty Publications
1200 Getty Center Drive, Suite 500
Los Angeles, California 90049-1682
www.getty.edu/publications

Elizabeth S. G. Nicholson, *Editor*
Jeffrey Cohen, *Designer*
Amita Molloy, *Production Coordinator*

Printed in Singapore

Front cover: Jean Bourdichon, *Bathsheba Bathing* (detail; see p. 51)
Back cover: Jean Bourdichon, *The Adoration of the Magi* (see p. 10)

**Library of Congress Cataloging-in-Publication Data**
Keene, Bryan C.
  Gardens of the Renaissance / Bryan C. Keene.
    pages  cm
  "This book is published on the occasion of the exhibition Gardens of the Renaissance, on view at the J. Paul Getty Museum at the Getty Center, Los Angeles, from May 28 to August 11, 2013."—ECIP galley.
  Includes bibliographical references and index.
  ISBN 978-1-60606-143-5 (hardcover)
1. Illumination of books and manuscripts, Renaissance—Exhibitions.
2. Illumination of books and manuscripts, Medieval—Exhibitions.
3. Gardens in art—Exhibitions. 4. Manuscripts, Renaissance—California—Los Angeles—Exhibitions. 5. Manuscripts, Medieval—California—Los Angeles—Exhibitions. 6. J. Paul Getty Museum—Exhibitions.
I. J. Paul Getty Museum. II. Title.
ND2990.K44 2013
745.6'709407479494—dc23
                                    2012048516

# Contents

axmona de scō sebastiano. Ant

Qua nirra refulsit
gratia scis sebasti
anus martir iditus
qui militis portans
insignia scd de fratrū palma solli

# Foreword

GARDENS ARE AN INTEGRAL ASPECT of both the Getty Villa and the Getty Center, beloved by staff and visitors alike. Herb beds, fragrant flowers, blooming bushes, and shaded hideaways provide sites where families picnic, artists sketch, children tumble on the grass, and museumgoers delight in the beauty of our light-bathed landscapes and plantings. Within the galleries, gardens abound in paintings, sculpture, drawings, manuscripts, and photographs, from a fifth-century B.C. red-figure pottery container showing the gardens of antique mythology to Vincent van Gogh's famous *Irises*, inspired by the garden flowers at the asylum in Saint-Rémy.

This book celebrates the Renaissance garden, which inherited the traditions established by the medieval monastic cloister and provided the foundation for the extravagant gardens of the Baroque period, such as Louis XIV's renowned Versailles. The volume gathers a wide range of objects from the Getty's permanent collection made between 1400 and 1600, with a focus primarily on the art of Renaissance book illumination. Vines twist and wind through page borders, the Virgin Mary seeks tranquility amid flowers and blossoms, exotic specimens from faraway lands are delineated in detail, and members of the nobility wander through plantings, admiring their possessions. These images enable an exploration of the varied aesthetic, religious, scientific, and economic meanings that gardens held in the Renaissance era.

Our thanks are due to Bryan C. Keene, curatorial assistant in the Department of Manuscripts at the J. Paul Getty Museum, for bringing the world of Renaissance gardens so vividly to life in the pages of this book. We are also grateful to the other departments that provided material and advice for objects reproduced here, including the Departments of Drawings; Paintings; Photographs; and Sculpture and Decorative Arts, as well as the Getty Research Institute's Special Collections. We thank Getty Publications for bringing this project to fruition and the Imaging Services Department for providing the inspired photography.

Robert Irwin, the designer of the Getty Center's main garden, once said of his creations, "Always changing, never twice the same." I hope that you will find this to be true as you explore the works in this volume, in the Getty's collection, and in its gardens.

TIMOTHY POTTS, *Director, The J. Paul Getty Museum*

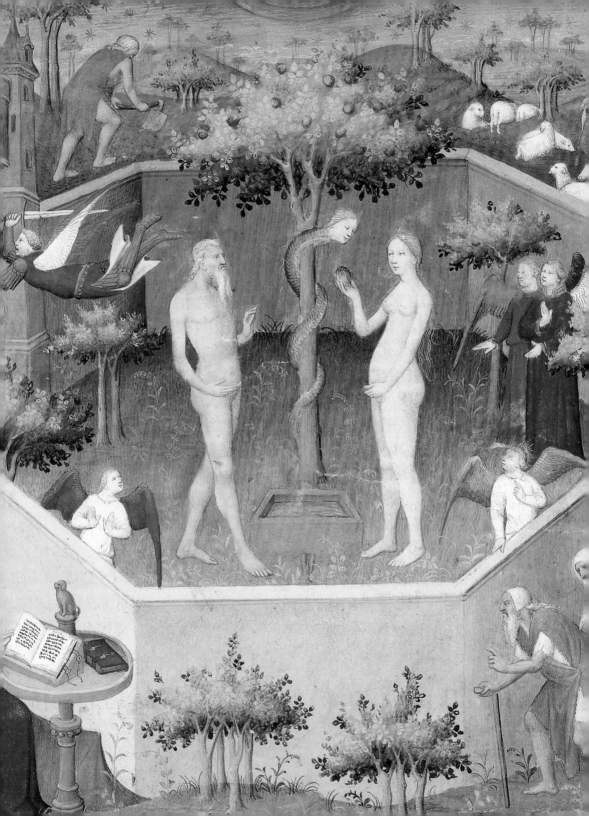

# Introduction

WHETHER CONNECTED TO GRANDIOSE VILLAS or common kitchens, gardens in the Renaissance were planted and treasured by all reaches of society. Some cultivated gardens for the display and study of beautiful and rare plants or sculptures both ancient and contemporary, while for others gardens provided necessary sustenance or a place for rest and meditation. Manuscript artists included images of gardens as illustrations for a variety of texts, and their depictions reveal the Renaissance spirit for the careful study of the natural world. In a society still dominated by the Church, gardens were also integral to the Christian visual tradition, from the paradise of Eden to the modest grassy enclosures associated with Mary and Christ. Gardens are by nature ephemeral, and most have changed or been lost since the Renaissance, but the objects in this volume offer a glimpse into how people at the time pictured, used, and enjoyed these idyllic green spaces.

The illumination showing a springtime scene in a Flemish book of hours, a private prayer book, provides a rich starting point in a survey of the pictorial traditions of gardens in the Renaissance because it encapsulates the many associations and conventions that stemmed from actual gardens at the time (fig. 2 and p. 13). A finely dressed noble couple watch two laborers tend to the first growths of spring in a small garden divided into parterres with topiaries and raised above the water surrounding a manor house. Following the line of the fence toward the bridge to the home is a trellised pergola arch, where a man trims the dead vines. A contextual understanding of the garden in the miniature might include the roles of men and women in the garden (both aristocratic and working class), the knowledge available at the time about seasonal plantings, the dietary habits of different social classes, the theories about effects of landscape and environment on health, and the relationship between architecture and gardens. The history of gardens in the Renaissance—from about 1400 to 1600—is therefore one of convergence. It encompasses a range of developments, from ancient and medieval precedents for enclosing and cultivating green spaces to the many advances made in science and medicine during the period (especially in botany and pharmacopeia), from the evolving societal roles of monasteries and courts to the varying geographical approaches for integrating architecture and landscape.

Gardens in the Judeo-Christian world are rooted in Eden, the paradise-like place watered by four rivers where God walked with Adam and Eve and where all seed-bearing plants grew in abundance. The etymology of the words *garden* and *paradise* denotes

I

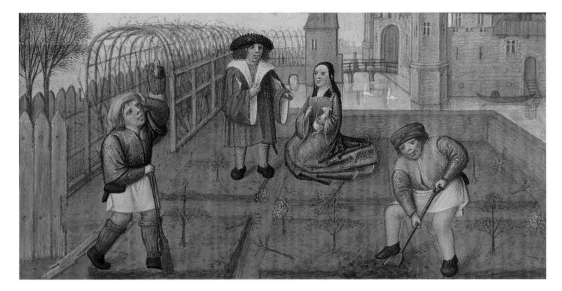

an enclosed, protected area, and yet artists of the Renaissance imagined Eden either as a lush and verdant landscape of unending proportions (p. 24) or as walled and guarded (fig. 1). These notions about paradise grew out of ancient Roman and medieval traditions, respectively. A close equivalent to the biblical concept of Eden in classical mythology, for example, was the "golden age," a period of peace at the beginning of time in which human, animal, and plant life lived harmoniously (artists often represented humans in the nude and within bucolic settings abounding with life). Some medieval cloister gardens, by contrast, were referred to as paradise on earth, walled spaces where monks could meditate and pray amid carefully planted beds of herbs, usually arranged into four quadrants (fig. 3 shows Saint Jerome, dressed as a cardinal, reading and sitting on a grass bench within a cloister).

Before the creation of botanical gardens associated with universities and pharmacies in Renaissance Europe, the medieval monastery provided a locus for the cultivation of known plant species. In these communities, ancient herbal medicine was practiced following the writings of Galen, Dioscurides, Theophrastus, and others. A seventh-century hermit-saint called Fiacre (fig. 4), for example, achieved fame as a skilled herbalist and healer; he likely gained his knowledge from Greco-Roman texts. He founded an oratory dedicated to the Virgin Mary that served as a hospice for travelers, earning him veneration as the patron saint of gardeners and those suffering from disease. Gradually through-

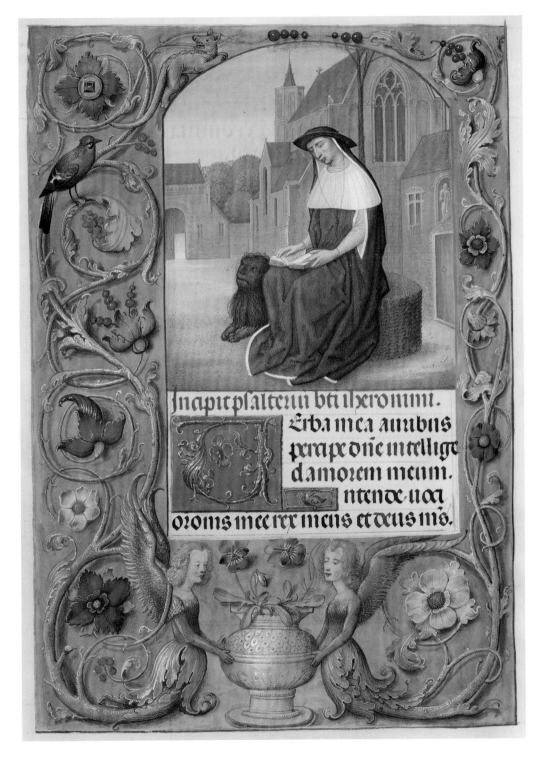

out the Renaissance, the court took greater involvement in the trade of plants through vast networks expanding to distant parts of the world, leading to increased knowledge about botany and pharmacopeia at the dawn of the era of natural history. This globalizing phenomenon coincided with a greater attention to naturalism in images of plants in manuscripts and other media.

Gardens at Renaissance courts were planted as signs of magnificence, as displays of power and control over the natural world, and thus as demonstrations of order. These gardens invigorated the senses through fragrant flowers gathered from all corners of the earth, an endless variety of colors and textures ranging from budding seedlings to rocky grottoes, the sound of water flowing from elaborate fountains or music from a theatrical performance, and the occasional outdoor meal with fruits and vegetables admired and tasted all around. Rudolf II, Holy Roman emperor from 1576 to 1612, owned many gardens throughout Europe, in which he grew a prized collection of natural wonders, including the then-rare tomato (fig. 5), imported from the Americas, and the tulip (see p. 71), the coveted rarity from an area in modern-day Turkey. The practice of depicting naturalistically rendered flowers in manuscripts, as in Rudolf's book of calligraphy,

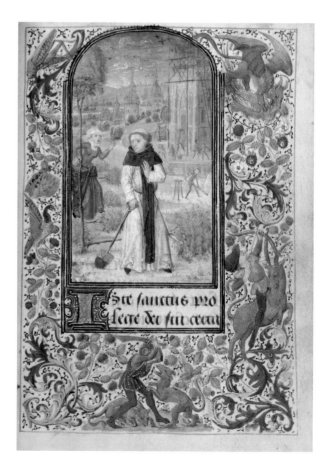

FIG. 4

**Saint Fiacre and the Shrew Houpdée (Becnaude or Baquenaude)**

Lieven van Lathem
Prayer Book of Charles the Bold
Ghent and Antwerp, 1469
Written out by Nicolas Spierinc
Ms. 37, fol. 38

FIG. 5

**Martagon Lily and Tomato**

Joris Hoefnagel
*Model Book of Calligraphy*
Vienna, written out by
Georg Bocskay, 1561–62,
illuminated ca. 1591–96
Ms. 20, fol. 102

dates to around 1480 in the southern Netherlands, when borders teeming with flowers became the hallmark style of books for private devotion produced in that region (see fig. 6 and p. 32–33).

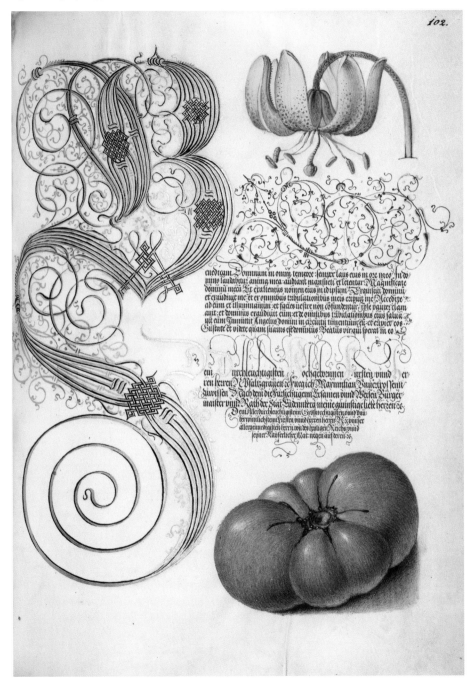

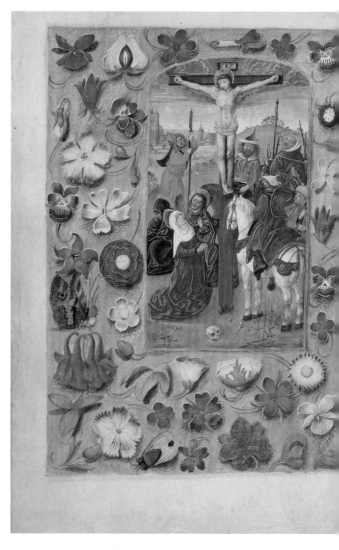

Considerations of a regional style or approach to actual gardens can prove difficult, since gardens in Renaissance Europe developed differently according to geography, even within a region today considered a single country, like Italy. The phrases *Italian garden* and *Renaissance garden* often identify gardens with symmetrical plantings that follow a sightline or axis from a villa and contain elaborate sculptural programs and waterworks. By contrast, *French formal garden* often denotes a more grandiose and planar garden type that emerged in France in the sixteenth century, inspired by Italian gardens but with greater emphasis on the arrangement of floral parterres than on creating architectural harmony.

The gardens examined in this volume present a number of paradoxes, since they are at times places of life and death (Eden), virtue and vice (the Garden of Love), betrayal

and salvation (the gardens of Christ), or the natural and the artificial (courtly gardens). The order and symmetry often associated with Renaissance gardens was imposed by human intervention, but at any moment nature could reclaim the site and introduce chaos. Images of gardens in the pictorial arts do not always resemble the verdant and flowering sites we might expect, and we should not assume that the visual attempts always reflect the physical reality of gardens from a particular place or time (although at times this assumption may prove accurate, even if somewhat fanciful, as in pp. 13 and 51). Today, through careful study of contemporary images of gardens in works of art from the Renaissance, we can still appreciate how people at the time attached various associations to gardens, including love, redemption, science, pleasure, healing, trade, and relaxation.

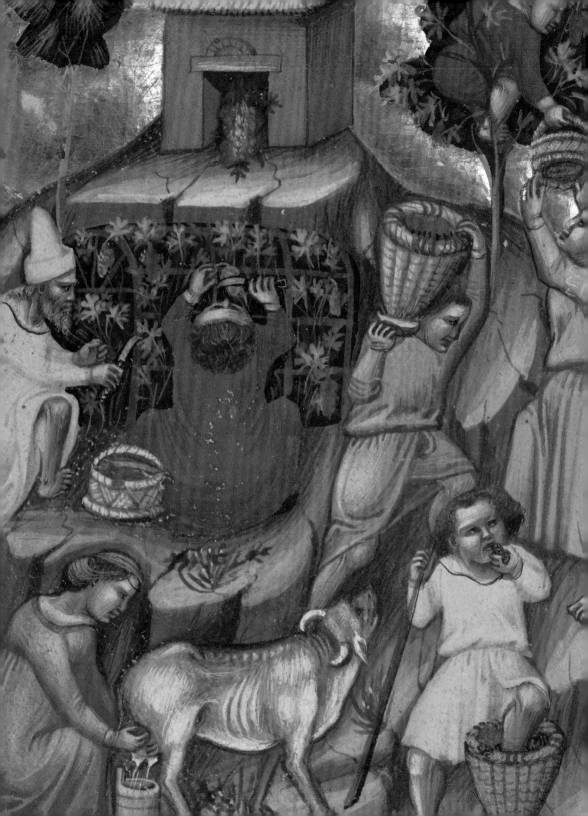

# Gardens in Life and Literature

"I entered into the garden ... and when I was inside ...
I thought that I was truly in the earthly paradise....
There was no paradise where existence was so good
as it was in that garden which so pleased me."

GUILLAUME DE LORRIS, *Romance of the Rose*

D URING THE RENAISSANCE, when gardens were planted in great
numbers, it was only natural that garden imagery permeated
the pages of manuscripts and printed books, from popular romances and
philosophical treatises to legal and devotional texts. As literary settings,
gardens were idyllic and sometimes imaginary spaces where lovers met,
courtiers retreated from city life, and adventurers sought an earthly para-
dise. Although the garden was also prevalent in art from the Middle Ages,
a hallmark of Renaissance depictions of gardens was an increased concern
for naturalism and the documentation of new and rare plant species.

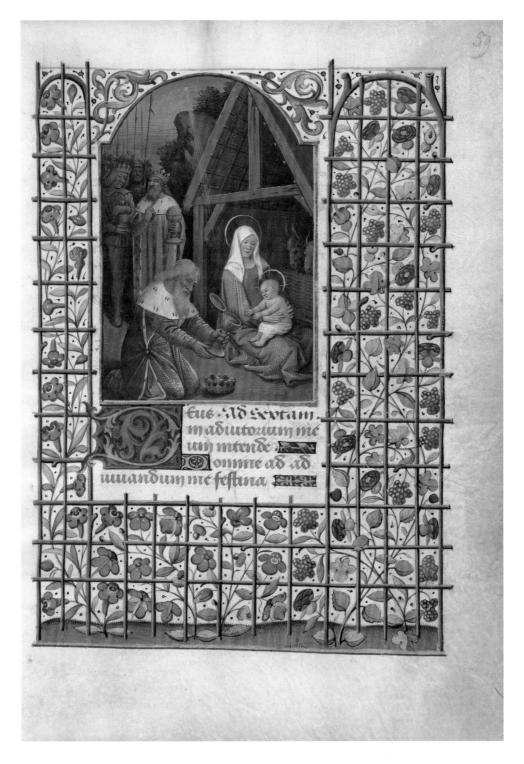

## The Adoration of the Magi

Jean Bourdichon
Katherine Hours
Tours, ca. 1480–85
Ms. 6, fol. 59

Trellised arches woven with flowers and grapes decorate the border of this image in a book of hours, a private prayer book for a layperson. Trellises were common in Renaissance gardens because they provided shaded walkways and helped vine plants to grow. The plants on the trellis on this page are not only decorative but symbolic. The grapes and red roses on the right were understood to refer to Christ's blood. The blue flowers are probably purple gromwell and speedwell, representing Christian salvation, and the red flowers with five petals are likely rose campion, associated with the Crucifixion. The flowers on both sides of the trellis therefore jointly signify salvation through Christ's sacrifice. In this context, the symbolic blooms appropriately surround an illumination of the three kings paying homage to the Christ child in recognition of Christ as the savior of humankind.

## Harvest Scene; Initial *U*: A Figure

Attributed to Illustratore
(Andrea da Bologna?)
Cutting from Justinian, *New Digest*
Bologna, ca. 1340
Ms. 13, verso

"Usufruct is the right to use and enjoy the property of another without impairing its substance." These words begin a chapter on agriculture in a book of Roman civil laws compiled at the request of the Byzantine emperor Justinian (r. 527–65), of which this miniature originally was part. The law of usufruct permitted individuals to plant a garden on a landed estate that was not their own and to eat the plants harvested there, but they could only sell seedlings for profit. The illuminator of this miniature added naturalistic details, such as the harvesting of grapes and the milking of a cow (a task mentioned elsewhere in the section on usufruct), to add vivid realism to an otherwise dry text.

## Poliphilo Surrounded by Nymphs

Francesco Colonna,
*Poliphilo's Strife of Love in a Dream*
Venice, 1545
87-B3229

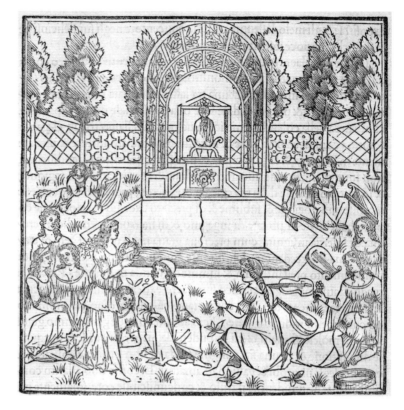

L ike the *Romance of the Rose* (pp. 17–21), this book relates a dream that takes place in a garden. The story focuses on the literary figure Poliphilo, who embarks on a journey to win back Polia, his beloved. The lovers visit the sacred island of Venus, goddess of love, where the ideal Renaissance garden grows: verdant groves abundant in fruit-bearing trees, lush forests separated from flowery meadows, and topiary shaped like and surrounded by classical sculptures.

In the lower center of this image, Poliphilo and Polia sit surrounded by nymphs and musical instruments. The garden was planted in memory of Adonis, one of Venus's lovers, who died on the spot (a sculpture of Venus sits atop the tomb). The pergola arch above the tomb and the fountain were typical features of Renaissance gardens, and here they adorn a memorial to love.

## The Nuremberg Residence and Garden of Magdalene Pairin

Georg Strauch
Genealogy of the Derrer Family
Nuremberg, ca. 1626–1711
Ms. Ludwig XIII 12, fol. 130 bis

T he text above the image explains that the house and garden pictured here were acquired in 1502 and formed an ancestral residence owned by Magdalene Pairin in Nuremberg, Germany. The garden is arranged into flower and vegetable beds surrounded by fruit trees. An aerial view of the garden is included to the left of the image, and a measuring line is drawn at the bottom of the page to provide a scale for the site. It is interesting to note that the garden appears from above today much the same as it did more than three hundred years ago when this manuscript was created. Local tradition refers to the region of Nuremberg as the garden of the Hesperides, mythical nymphs who tended a grove of golden fruit-bearing trees (the Nuremberg gardens grow citrus trees).

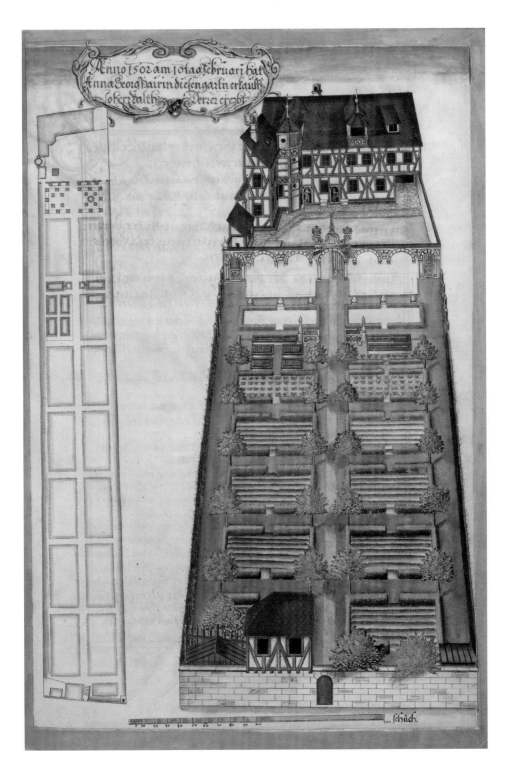

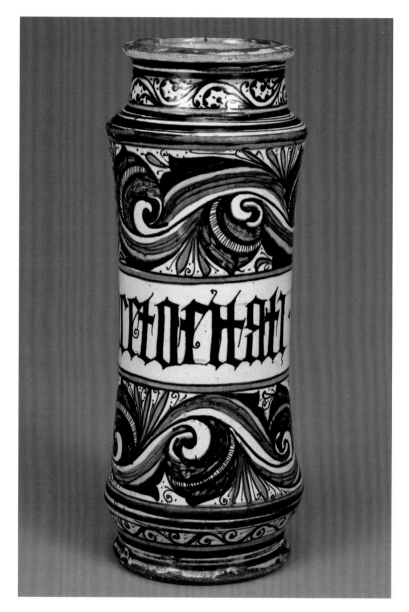

**Drug Jar for Persian Philonium**

Faenza, ca. 1520–40
Tin-glazed earthenware
H: 37 cm (14⁹/₁₆ in.);
Diam (at lip): 12.5 cm (4¹⁵/₁₆ in.);
Max. W: 16.5 cm (6½ in.)
84.DE.105

Gardens and ceramic objects share an interesting history. Renaissance pharmacies and some aristocratic households often displayed storage containers with the ingredients of medicinal remedies, which frequently consisted of minerals and herbs grown in a *giardino dei semplici* (garden of simples, or herbs). Tin-glazed earthenware drug jars were thus practical but also beautiful, emphasizing the value of the vessels' contents. Persian philonium, the name of a drug painted across the center of this jar from Faenza, Italy, was used to relieve the pain of menstruation and hemorrhoids, to induce sleep, and to prevent miscarriages. The ingredients were saffron, white pepper, pearls, amber, and opium, which no doubt contributed to its efficacy.

14

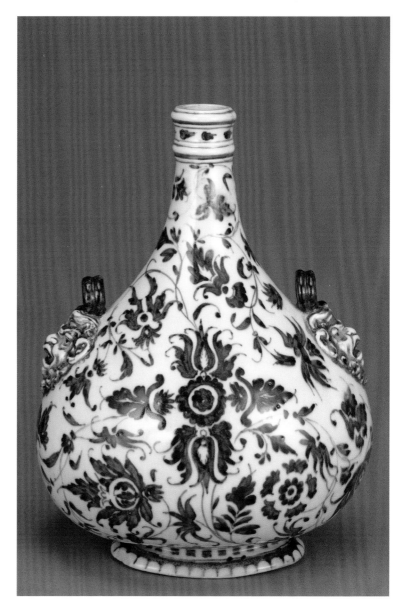

**Pilgrim Flask**

Medici Porcelain Factory
Florence, 1580s
Soft-paste porcelain, underglaze
blue decoration
H: 26.4 cm (10⅜ in.); Diam (at lip):
4.8 cm (1⅞ in.); Max. W: 18.7 cm
(7⅜ in.)
86.DE.630

One of the earliest European attempts to make a satisfactory form of porcelain, a long-coveted commodity imported from China, took place at the Medici court in Florence. Under Duke Francesco I de' Medici, artisans first successfully produced the traditional blue-and-white objects at the Casino di San Marco, a modest villa just north of the city center that boasted a simples garden whose herbs were used in all forms of alchemical experiments, including the manufacture of porcelain. The shape imitates that of the flasks made of leather and filled with water that travelers and pilgrims carried, and the decoration contains stylized roses, carnations, and tulips, as well as grotesque heads on either side.

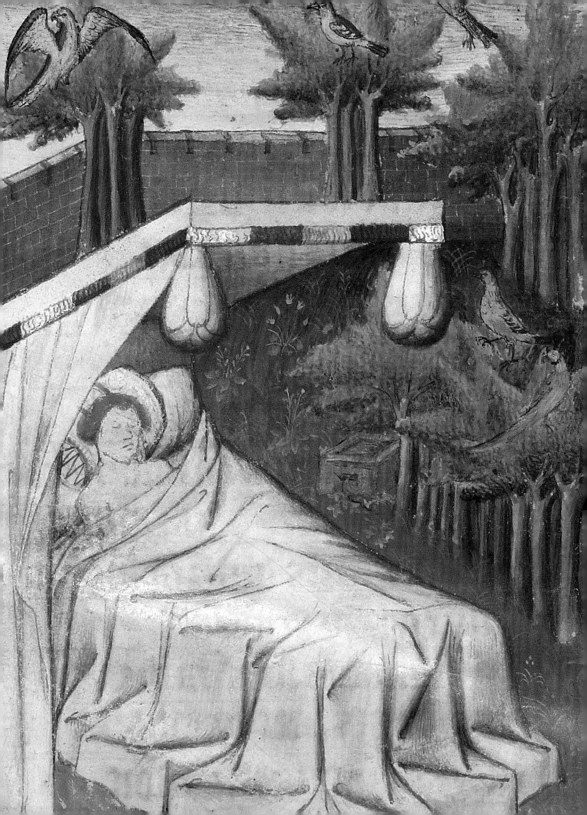

# Dreaming of Gardens

## *Romance of the Rose*

*Romance of the Rose* is an allegorical, chivalric poem that celebrates the mythical Garden of Love, dedicated to Venus, the goddess of love. Illuminated copies of the text feature a variety of scenes representing events that took place both inside and outside the garden walls.

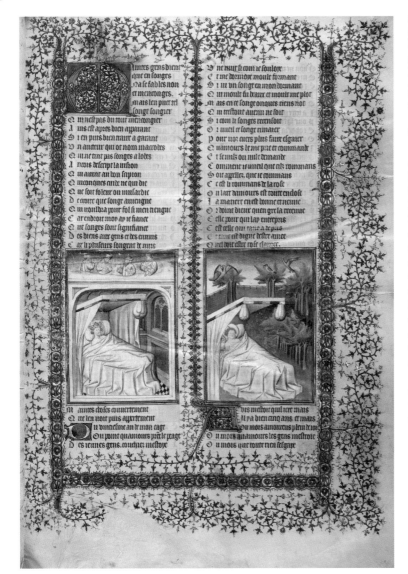

**Scipio Lying in Bed Dreaming; Guillaume de Lorris Lying in Bed Dreaming**

Guillaume de Lorris and Jean de Meun,
*Romance of the Rose*
Paris, ca. 1405
Ms. Ludwig XV 7, fol. 1

The opening lines of *Romance of the Rose* compare two dreams, one historical (shown at left) and the other fictional (at right). In the author's dream, the Lover first enters a lush, enclosed garden described as an earthly paradise filled with songbirds. There he encounters Cupid and other figures representing vices and virtues, before he attempts to free a rose that represents the affection of his lady. The garden is described throughout as a site of love and of temptation. Ultimately, the romance illustrates the most successful tactics for wooing the affection of a woman.

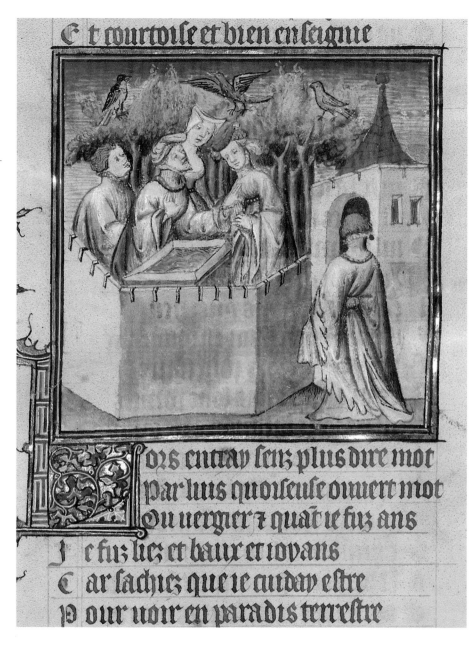

**The Lover Views the Garden**

Guillaume de Lorris and
Jean de Meun,
*Romance of the Rose*
Paris, ca. 1405
Ms. Ludwig XV 7, fol. 5v

The Lover stands at the gate to the garden, in which he will encounter companions like the God of Love and Lady Wealth, who will guide him in his journey to overcome Sorrow and Jealousy and ultimately reach his beloved rose. The garden is filled with trees, a fountain, and birds.

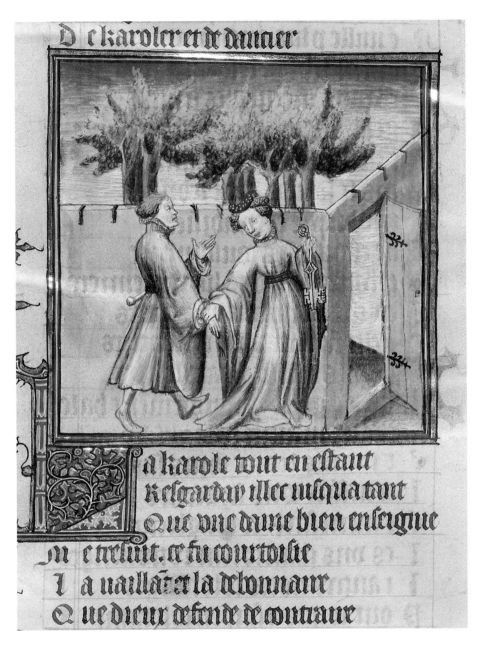

The Female Personification
of Courtesy Opening
a Garden Door to the Lover

Guillaume de Lorris and
Jean de Meun,
*Romance of the Rose*
Paris, ca. 1405
Ms. Ludwig XV 7, fol. 6v

The courtly theme of the poem continues with a fashionable maiden, Courtesy, who opens the door to the garden with a set of keys. Within the poem, the Lover notes that the tall trees clearly visible from beyond the garden walls were carefully selected for their beauty.

**Narcissus Gazing at His Reflection**

Guillaume de Lorris and
Jean de Meun,
*Romance of the Rose*
Paris, ca. 1405
Ms. Ludwig XV 7, fol. 11

Fountains are quintessential features in a garden, and here
the mythological figure Narcissus begins to fall in love with
his own reflection in the mirror-like clear waters, ignoring the
romantic advances of a nymph called Echo. The Lover encounters
the fountain of Narcissus after viewing all other parts of the
garden. In the fountain he sees a rosebush and singles out the most
beautiful rose as his true love.

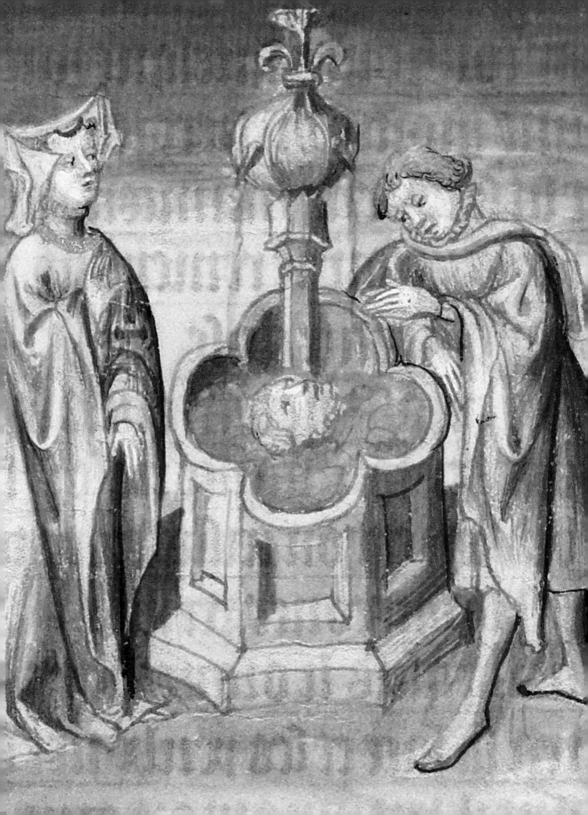

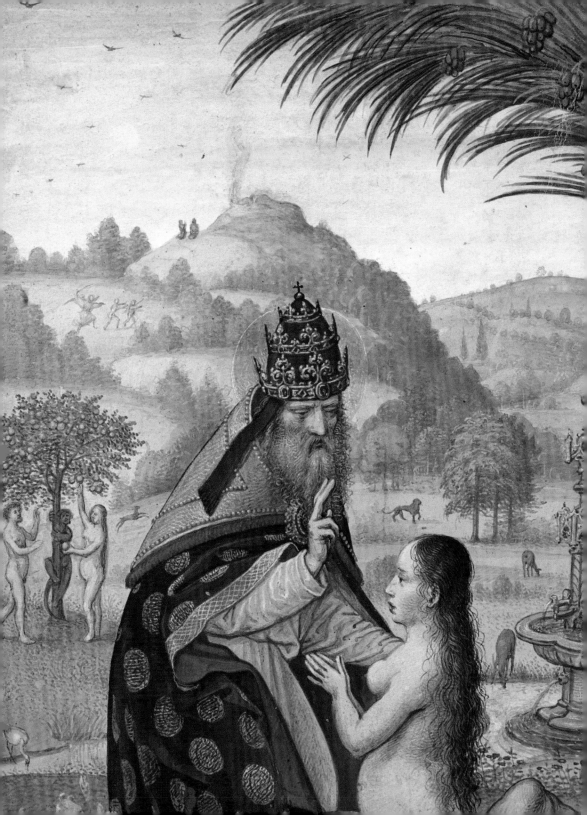

# Biblical Paradise
# on Earth

"And the Lord God planted a garden eastward in Eden,
and there he placed the man whom he had formed.
The Lord God made all kinds of trees grow out of the
ground, trees that were pleasing to the eye and good
for food."

GENESIS 2:8–9

IN THE BIBLE, the story of Christian salvation is rooted in gardens, from Adam and Eve's sin in the Garden of Eden that begins the Old Testament to Christ's resurrection in a Jerusalem garden in the New Testament. Renaissance theologians and adventurers sought to map and discover the location of Eden, while pilgrims risked the dangers of travel to visit the gardens that Christ had frequented. For most other devout Christians, tranquil manuscript images of Mary in a garden facilitated devotion and prayer. Artists often represented Eden as a verdant orchard with high walls, while the gardens associated with Mary and Christ tended to be smaller, enclosed by a simple wooden fence.

### Scenes from the Creation

Simon Bening
Prayer Book of Cardinal Albrecht
of Brandenburg
Bruges, ca. 1525–30
Ms. Ludwig IX 19, fol. 7v

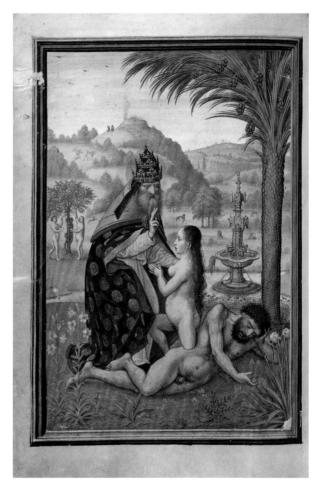

S imon Bening's scene evokes an understanding
of Eden not as a walled space but as a vast
and verdant landscape. The Garden of Eden was
described in Greek and Latin translations of the
Bible throughout late antiquity and the Middle
Ages as *paradise*, a word derived from ancient
Mesopotamia and used to refer to an enclosed
royal hunting park filled with wild animals and
fruit-bearing trees. In the foreground, God the
Father, dressed in papal vestments, creates Eve
from Adam's side. Surrounding the group are
lilies, irises, lilies of the valley, roses, and a date
palm (perhaps signifying the supposedly eastern
location of Eden, as such trees were imported
from beyond Europe). Water issues from an
ornate golden fountain to create a small lake with
streams, perhaps a reference to the four rivers
that flowed from Eden (see p. 29). Opposite the
fountain, Adam and Eve share the forbidden fruit.
In the midground landscape, a lion and several
deer roam. In the background, the first couple
is expelled from Eden, and their sons, Cain and
Abel, offer sacrifices.

---

### The Story of Adam and Eve

Boucicaut Master
Giovanni Boccaccio,
*Concerning the Fates
of Illustrious Men and Women*
Paris, ca. 1415
Ms. 63, fol. 3

W ithin the octagonal enclosure of the Garden of Eden, Eve offers Adam fruit
from the tree of knowledge of good and evil, on which winds a female-headed
serpent representing Satan. At the base of the tree is a fountain, which waters the
flowery field. The narrative continues as Adam and Eve are expelled from Eden (at
left) and forced to labor in the field and at the loom (above) as punishment for their
sin. As an elderly couple, represented below, they will present their story to Giovanni
Boccaccio, author of this moralizing text about the fortunes and misfortunes of
famous men and women, beginning with Adam and Eve.

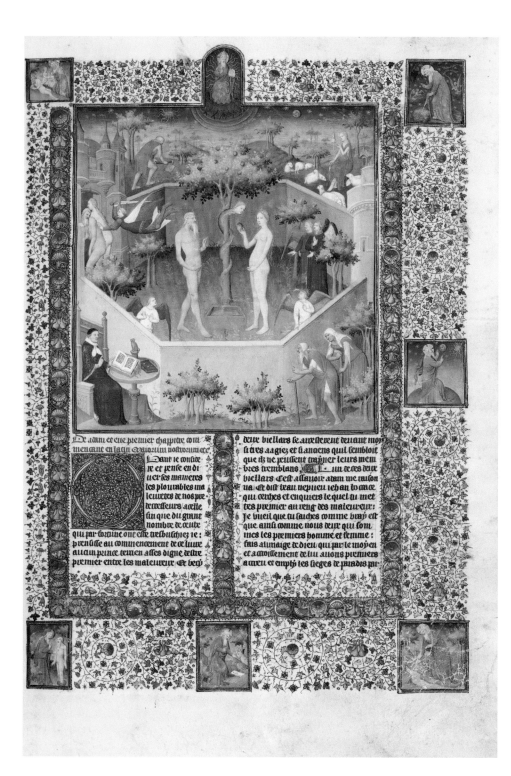

**Adam and Eve
Eating the Forbidden Fruit**

Master of the Oxford Hours
Saint Augustine,
*City of God*
Probably Nantes, ca. 1440–50
Ms. Ludwig XI 10, fol. 31v

**The Expulsion from Paradise**

Master of the Oxford Hours
Saint Augustine,
*City of God*
Probably Nantes, ca. 1440–50
Ms. Ludwig XI 10, fol. 41

S urrounded by citrus trees and wildflowers, Adam and Eve eat from the tree of
knowledge planted at the center of the Garden of Eden, referred to in this
text as paradise. The image opens a section of the *City of God* in which the Christian
theologian Saint Augustine (354–430) defines paradise as both a real place on the
earth—"a well-wooded and fruitful spot"—and a spiritual allegory for salvation.
A few pages later in the same manuscript, Adam and Eve are expelled from paradise,
whose forbidding crenellated walls resemble medieval architecture.

ou defirs de couraige foient bonnes ou mau-
uaifes. ·vij·

Sic on trouue es faintes efcripture a-
mour et dilection indifferentment en bien et
en mal. ·viij·

Les liure perturbation que les ftoyciens
uoulurent eftre ou couraige ou penfee de lomme
faulue hors mife douleur ou trefteffe. fes aiftes
fa vertu du couraige ne doit point fentir. ·viiij·

Les perturbacions du couraige des aiftes
la vie des iuftes a biaux defirs ou biaux af-
fections. ·xv·

Sic on dit q̃ tout les premiers hommes
auoir efte tellement mis en paradis que ils ne
feuffent toufuiefter. de quelques perturbati-
ons auant q̃ils peuffent feir. ·x·

Du trebuchement du premier homme ou
quel nature fut bn cree et laquelle ne peut
eftre reuee fors par fon auteur. ·xi·

De la qualite du premier pehc come par
fommje. ·xij·

Sic en la preuaricacion de adam mau-
uaife uoulte preceda a mauuaife euure. ·xiij·

De loultel de la tranfgreffion la quelle
mefmee fut pire que la tranfgreffion. ·xiiij·

De la retribucion de la iuftice que les pre-
miers uintes deceurent pour leur defobei-
fance. ·xv·

Du mal de delectation le nom du quel co-
uient que il fe rapporte et ait regart a plu-
feurs vices toutefuoiee eft il attribue propre-
ment auir vile et oes mouuemens du cueur. ·xvj·

De la maudie des premiers hommes laquel-
le ils uirent faire honte fe apres ce quelx
eurent pehc. ·xvij·

De la hute de honte et fente habiter en-
femble nõ me publiquement mais auffie
a mariage ou en maice. ·xviij·

Sic les parties de uie ou de coudure
et de luxure ou delectation charnele fe meu-
uent fi vicieufement et fi laudment que il
eft neceffite de les reftraindre par les frains
de fapience. les quelles chofes refuroet vne
auant q̃ pehc en celle fainete de nature. ·xix·

De la tref amie laudure des vintes. ·xx·

De la beneifon de multiplier lumain
fumaige auant pehc laquelle ne fut pas
oftee par le pehc de preuaricacion et a qui
foit uenue cefte maladie de luxure ou defec-
tation charnele. ·xxj·

De laffemble de mariage premierement
inftituee et benoifte de dieu. ·xxij·

Signon fe on euft auffi fait generation
en paradis fe nul neuft pehc on fe on euft bu
le chaftier qui fauft illecques puir foy combat-
tre contre la chaleur de luxure ou delectatio
charnele. ·xxvij·

Sic les homes innocens & amoureux en
paradis par fainete obedience auffent ufe
de laurs niebres ifeconttre a faire generatio
a leur uoulente auffi comme de leurs au-
tres membres. ·xxviij·

De la maue beneurte laquelle la vie
temporele na mie. ·xxvij·

Sic il eft a auoir que la beneurte ou feli-
cite du paradis des uiuans eft a dire ter-
uftre puift fans honteur appetit auon acom-
pliffoe & entendier. ·xxix·

Les auftres et hommes pefuare la mau-
uaiftie des quelx ne empefche en rien fa pro-
uidence de dieu. ·xxx·

De fa qualite des deux citez ceftaffe & la
terrienne et de la celeftienne. ·xxxj·

Cy finent les rebriches. Et commence en a-
pres le xvij·e liure de la cite de dieu.

Comment par la defobeiffance du premier
homme tous feuffent turbuchez en la punda-
bleste de lamort fecode fe fa grace de dieu nen
euft deliure plufieurs.

Nous auofns ne dit es liures
precedens que non me a a
commencement fumain fingula-
ne par femblate de nature
tant feullement. mais auffi
a la fter enfemble iung lien de cuy auffi
come couvert en vne vinte par vne maniere
& equation damour et & difeation fteu vn

confuz .et delaiſſerent leur propoz
et ſen alerent en diuerſes regions
ſelon la diuerſite de leurs langues
Les filz de ſem demourerent en
aſie . Les filz de cham en auffrique
Et les filz de japhet en europe .
yſidorus diſt que le monde eſt de
uiſe en troiſ parties . non pas
eſcaulz . Car il diſt que aſie com
mence de midi par deuere oriét
iuſques a ſeptentrion . Et europe
comence de ſeptentrion iuſques
en occident . Et auffrique comece

de occident iuſques a midi . Et
ainſi aſie tient la moitie du monde
Et europe et Auffrique contiennét
toute laultre . Et ſont ces deux
parties ſi faictes que la treſchau
mer entre entre deux et les deuz
ſe line de laultre .

Et en ceſt chapitle deuiſe de la terre
daſie . et comment elle eſt aſſiſe .
Et de paradis terreſtre qui eſt
ſon premier bout . ſicomme les
eſcriptures diſt . Cyp̄.

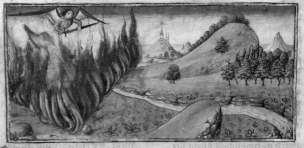

ſe ſurnommee du
nom dune femme
qui auoit nom Aſe
qui tind ancheinnement lempire
orient . Et eſt aſie ordonnee en la
tiere partie du monde . Et comen
ce en orient . et dure par deuere
midi iuſques en la grant mer .
et ſeniſt en noſtre mer par deus
occident . et par deuere ſeptentri
on ſeniſt ou lac meothidieu . et
ou fleuue de chanap . Et ceſte
partie a mouſt de regions et de
prouinces . Et le comencement
eſt en paradis . Et paradis eſt

autant a dire comme lieu de de
lices . et eſt ez parties doriet . Et
celi lieu eſt plain de toutes mame
res de boiz portant fruit . et reſt
le fuſt de vie . Il ny fait trop chau
ne trop froit . et y eſt laer trop a
tempre . Et ou milieu ſourt vne
fontaine qui arrouse tout le ien .
et eſt celle fontaine deuiſee en ᵐ
fleuues . Et lentree de celui lieu
eſt dente a tout des que a dam
ot dedens peche . Et eſt chamt
tout entour de mur de feu flam
bant . et ſamble que celle ſiambe
iomgne iuſques au ael . Et

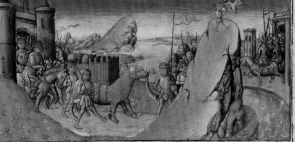

The Angel of Paradise with a Sword;
The Land of India

Vincent of Beauvais,
*Mirror of History*
Ghent, ca. 1475
Ms. Ludwig XIII 5, vol. 1,
fols. 54v–55

Beginning with the biblical creation story and extending to the year 1254, this comprehensive history of the world locates earthly paradise (*paradis terrestre*) in Asia. The text does not refer to paradise as the Garden of Eden, as it was sometimes called, but describes a delightful place filled with every type of fruit-bearing tree and a fountain flowing throughout. These wonders are hidden by a wall of fire (at left), guarded by an angel after Adam and Eve's expulsion from paradise. The description of paradise continues with a discussion of the marvels of India, including what is supposed to be an elephant (at right). By locating paradise in the extreme East, the author follows a medieval tradition that considered Eden almost unreachable.

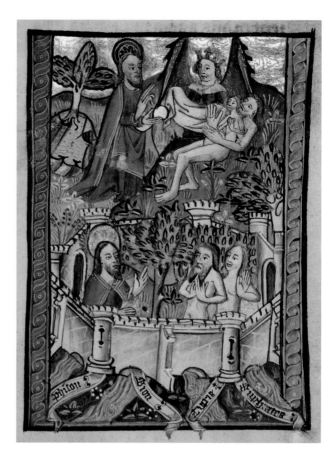

**The Garden of Eden**

Illustrated *Vita Christi*
(Life of Christ), with
devotional supplements
East Anglia (perhaps Norfolk),
ca. 1480–90
Ms. 101, fol. 8

This image of the Garden of Eden draws its visual cues from a passage in the second book of Genesis, included on the facing page in the manuscript. The text states that God placed Adam and Eve in an "earthly paradise," which in the Renaissance became synonymous with orchards, botanical gardens, and cloister gardens. In the image, Eden's walls divide the narrative between creation above and the imminent expulsion from paradise below, after the couple eats the forbidden fruit. The text describes four rivers flowing from Eden, which the artist labels as the Pison (possibly in Syria), the Gihon (said to be in Ethiopia), and the Tigris and Euphrates (mostly in modern-day Iraq). Mention of these rivers caused some in the Renaissance to interpret Eden as a real place, and mapmakers often attempted to locate it.

**Adam and Eve
Eating the Forbidden Fruit**

Willem Vrelant
Arenberg Hours
Bruges, early 1460s
Ms. Ludwig IX 8, fol. 137

Of all the trees and seed-bearing plants that grew in the Garden of Eden, two received special mention in the first book of the Bible, Genesis: the tree of knowledge of good and evil and the tree of life. God forbade Adam and Eve to eat the fruit of the former tree because it brought death, but he promised that by eating the fruit of the latter, they would live forever. In this miniature, the two trees become symbolically one. Christ's sacrifice on the cross redeemed humanity and formed a bridge between the lost earthly paradise and the one to be regained for eternity in heaven (the celestial paradise).

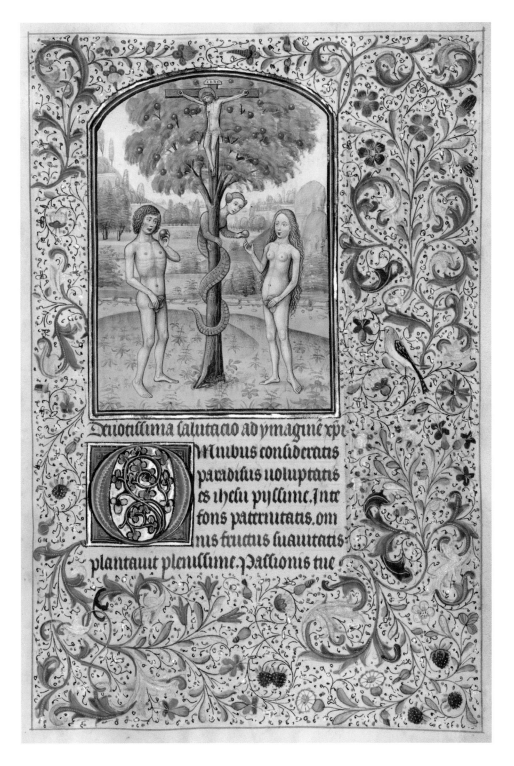

Deuotissima salutacio ad ymaginē xpī
ribus consideratis
paradisus noluptatis
es ihesu pyssime. Inte
fons patrinitatis. om
nis fructus suauitatis
plantauit plenissime. Passionis tue

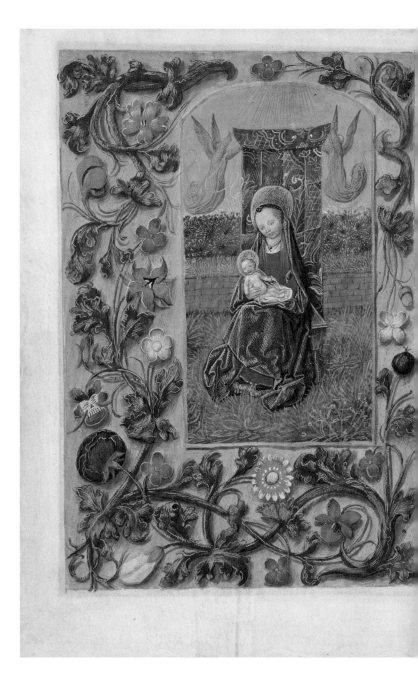

## The Virgin and Child Enthroned; Initial *S*

Master of the Dresden Prayer Book
or Workshop
Crohin–La Fontaine Hours
Bruges, ca. 1480–85
Ms. 23, fols. 29v–30

The Virgin Mary sits in a garden with the Christ child on her lap as two angels hold a patterned cloth above them to form a symbolic throne. Behind them is a turf bench, a typical garden feature, made from bricks and grass and backed by a hedge of roses. Beginning in the Middle Ages, theologians interpreted a line from a lyrical poem in the Bible's Song of Solomon as referring metaphorically to the Virgin Mary: "You are an enclosed garden, my bride." Thereafter the garden became a frequently used symbol of Mary's sin-free birth and virginity.

Representations of Mary in a private garden are particularly well suited for devotional images, since patrons could imagine themselves in a similar tranquil setting.

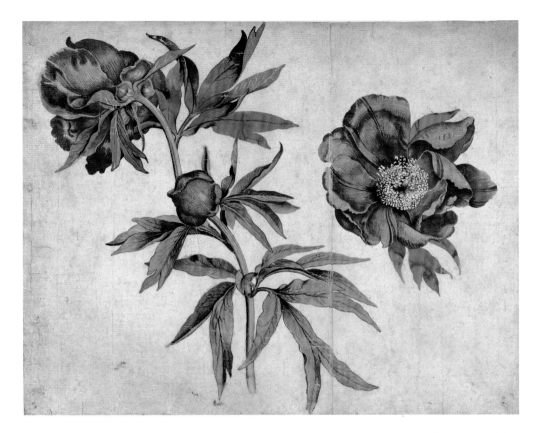

**Studies of Peonies**

Martin Schongauer
Germany, ca. 1472–73
Gouache and watercolor
on paper,
25.7 × 33 cm (10⅛ × 13 in.)
92.GC.80

Considered one of the greatest graphic artists, Martin Schongauer used this meticulous and highly finished watercolor as the basis for some of the peonies in his most famous painting, *The Madonna of the Rose Garden*, in the Dominican church of St. Martin in Colmar, France. In the painting, the peony symbolically refers to Mary as "a rose without thorns," since peonies, unlike roses, lack thorns. Interest in natural history increased throughout the late fifteenth century, as evidenced by Schongauer's botanical precision in presenting these three peonies, two in full bloom (from the front and from behind) and one as a bud.

---

**The Holy Family**

Jan Gossaert (called Mabuse)
Netherlands, ca. 1507–8
Oil on panel,
46 × 33.7 cm
(18⅛ × 13¼ in.)
71.PB.45

The Holy Family appears before a private courtyard garden. Theologians like Saints Jerome, Ambrose, and Bernard of Clairvaux wrote about the symbolic relationship between Mary's virginity and the closed garden and sealed fountain mentioned in the Song of Solomon. In response to these writings, a pictorial tradition in which Mary was depicted in an enclosed garden setting developed in the Middle Ages and continued into the Renaissance. The vase in the foreground contains flowers that reinforce the garden theme and refer simultaneously to Mary and to Christ: roses (Mary as the thornless rose; Christ's blood), lilies (Mary's purity; Christ's resurrection), and irises (Mary's tears; the spear that pierced Christ's side). The three female nudes in the lowest register of the nearby fountain are based on an image in Francesco Colonna's text *Poliphilo's Strife of Love in a Dream*, which Gossaert likely encountered through a printed edition.

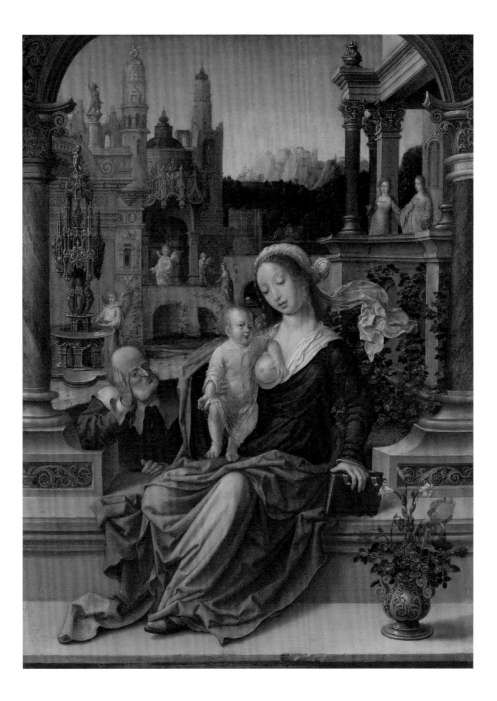

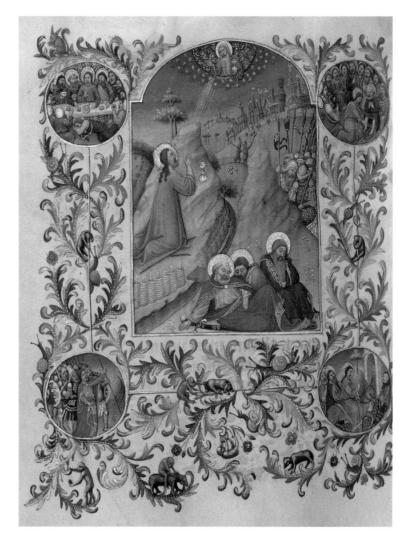

**The Agony in the Garden**

Spitz Master
Book of Hours
Paris, ca. 1420
Ms. 57, fol. 169v

On the evening before the Crucifixion, Christ prayed with his disciples in a place beyond the walls of Jerusalem where they often went for meditation and respite. The Gospels refer to this location either as the Mount of Olives or the Garden of Gethsemane, which artists often conflated into one setting. The site traditionally associated with the Garden of Gethsemane is located on the slopes of the Mount of Olives outside Jerusalem, a fact attested by numerous medieval and Renaissance pilgrim accounts of the Holy Land. In this illumination, Christ kneels at the base of the Mount of Olives, which is surrounded by a wattle fence to represent the Garden of Gethsemane. The walls of Jerusalem can be seen in the far distance. At top, God the Father blesses Christ, who grapples with his imminent death. The roundels in the border contain events leading up to the central scene, beginning in the lower right with Christ's entry into Jerusalem, Christ washing the disciples' feet, the Last Supper, and Judas's betrayal.

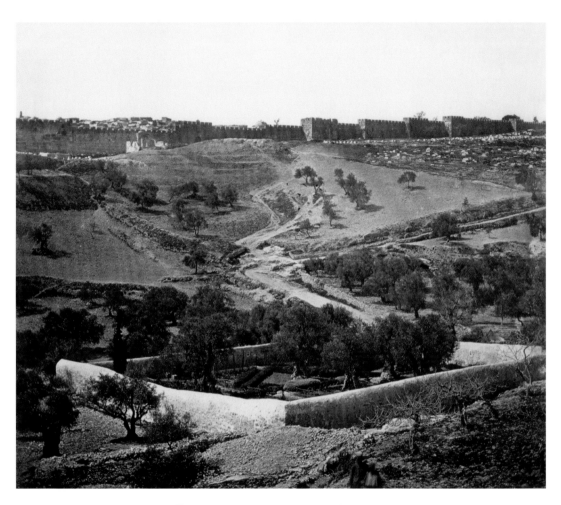

### The Garden of Gethsemane

James Robertson,
Felice and Antonio Beato
1857
Albumen silver print,
26.2 × 30.2 cm
(10⁵⁄₁₆ × 11⅞ in.)
84.XA.755.7.52

James Robertson and the Beato brothers traveled to the Holy Land and documented in photographs the important religious monuments and locales there. Some published prints of this photograph were accompanied by text that described an "ancient garden" that existed on the site where Christ prayed. Indeed, the earliest documented garden on the site dates to the fourth century, and from the thirteenth century until the present it has been under the care of Franciscan monks. The composition of the photograph contrasts the rough crenellated walls of Jerusalem at the top with the bright white fence of the garden below. In the foreground, two blurred figures provide a sense of scale. The garden itself is in crisp focus, allowing the viewer to make out trellises and hedges surrounding olive trees inside.

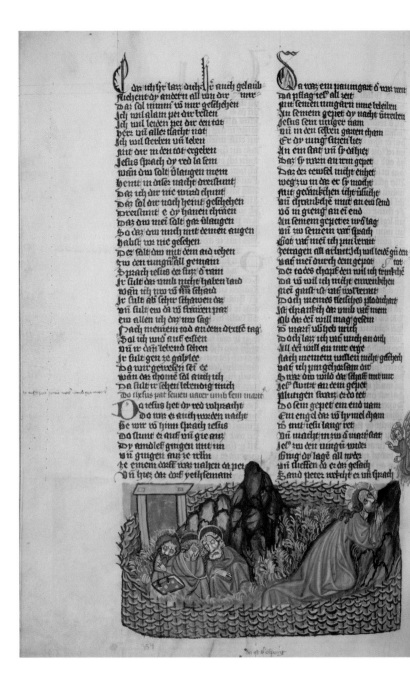

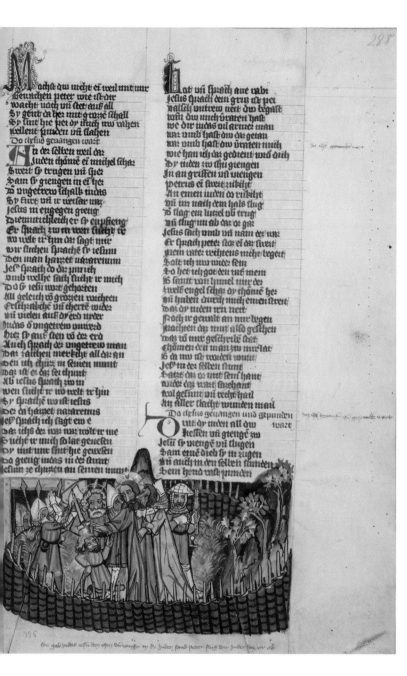

## The Agony in the Garden; The Betrayal of Christ

Rudolf von Ems,
*World Chronicle*
Regensburg, ca. 1400–10
with addition in 1487
Ms. 33, fols. 287v–288

Two events from Christ's passion are shown here in a garden surrounded by a wattle fence. At left, Christ asks God the Father if an alternative to death is possible for the salvation of humankind. In response, an angel descends from heaven and gestures that Christ's sacrifice is required. Later, at right, the traitor Judas leads soldiers to arrest Christ. In anger, the disciple Peter cuts off the ear of one of the attendants, but Christ heals the wound. The artists who illuminated this manuscript employed a variety of pictorial strategies for exploring narrative events, here showing a continuous sequence of events that spans two pages. During the Renaissance, pilgrims frequently traveled to and prayed in the Garden of Gethsemane in imitation of Christ, and the images in this text complement the idea of following Christ's example in prayer.

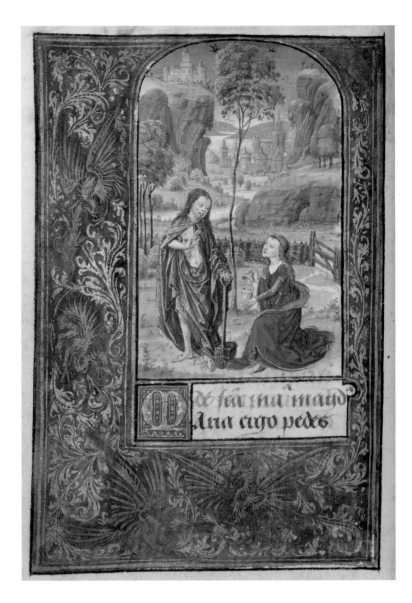

**Noli me tangere**

Lieven van Lathem
Prayer Book of Charles the Bold
Ghent and Antwerp, 1469
Written out by Nicolas Spierinc
Ms. 37, fol. 46v

Mary Magdalene kneels before the resurrected Christ within a modest fenced garden. According to the Bible, after the Crucifixion, Christ was buried on a plot of land containing a garden. Mary initially mistook Christ for a gardener, and thus artists in the Renaissance often depicted him holding a shovel, as in this scene. The tall tree at the center of the image not only suggests a garden setting but likely refers to the tree of life that grew in Eden, serving as a reminder that Christ's atoning sacrifice for the sins of humanity provided everlasting life in heaven.

Lieven van Lathem excelled in landscape painting, a new genre in the Renaissance. While the garden in the image does not contain lavish plantings, Van Lathem's attention to atmospheric perspective, color, and light effects enhances the scene.

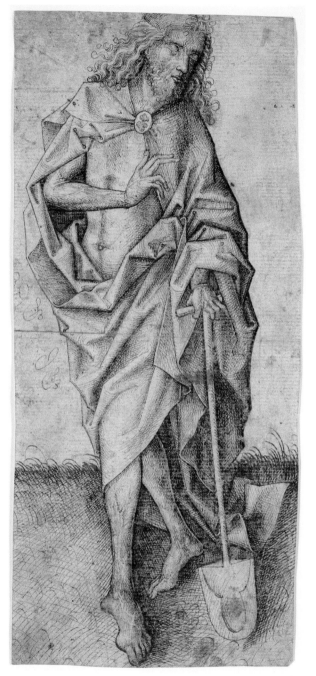

## Christ as the Gardener

Upper Rhenish Master
Germany, ca. 1470–90
Pen and gray-black ink
on paper,
24.1 × 10.8 cm (9½ × 4¼ in.)
2003.11

According to the Gospel of John, Christ appeared to his follower Mary Magdalene in the garden, where he was buried, three days after the Crucifixion. At first, Mary thought Christ was a gardener, but when she recognized him she rejoiced. Christ gestures as if to tell an absent Mary not to hold on to him since he must ascend to heaven. Although this sensitive figure study only shows Christ amid some grass, the garden shovel is a clue to understanding the narrative moment. The gardener Christ reminds viewers of Eden and of Christ's atoning sacrifice for sin, which promised eternal life in heaven.

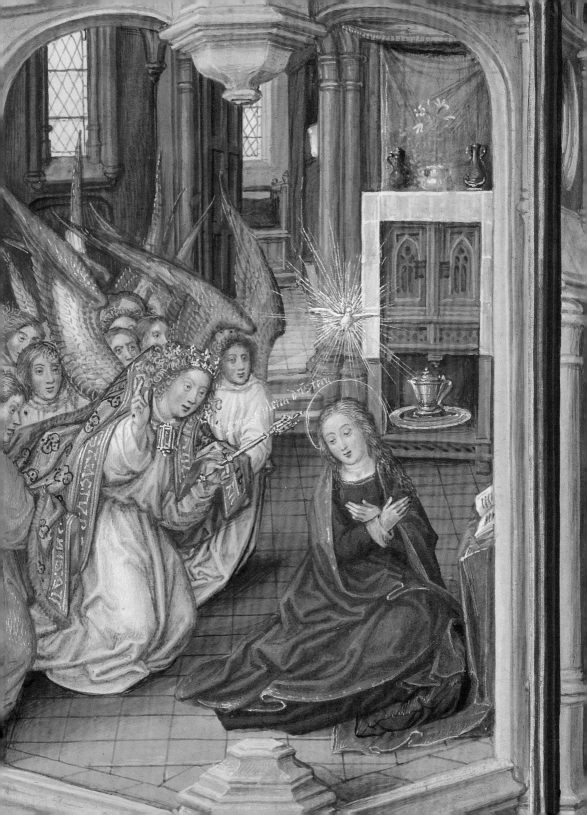

# Holy Figures and Flowers

## The Spinola Hours

Various artists adorned the borders of this prayer book with flowers painted with close attention to detail, as was typical in Flemish illumination. Some flowers are strewn gracefully, while others grow from pots or vases. Narrative scenes include sixteenth-century garden settings, which encouraged patrons to imagine themselves as bystanders to the stories.

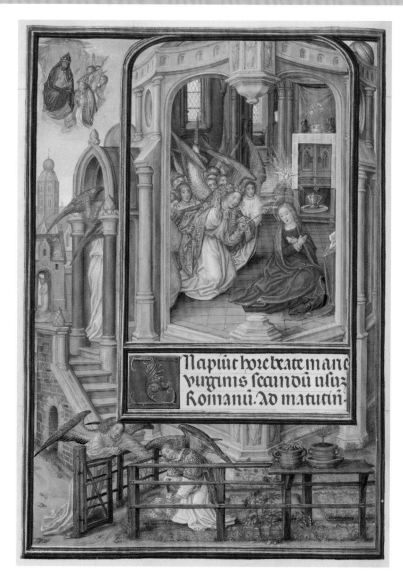

**The Annunciation**

Master of James IV of Scotland
Spinola Hours
Bruges and Ghent, ca. 1510–20
Ms. Ludwig IX 18, fol. 92v

At the bottom of this image, two angels tend the Virgin Mary's private garden, arranged with square beds of flowers including roses, lilies, and columbines. One angel picks a lily, which symbolizes Mary's sin-free birth. In the home above, another lily is visible in a vase atop a wooden cabinet. The angel Gabriel, joined by an angelic retinue and the dove of the Holy Spirit, tells Mary that she will give birth to the Christ child, and she accepts the news with humility. In the sky beyond the house, Gabriel is shown again, kneeling before God the Father in heaven.

In Annunciation scenes, Mary is often shown near an enclosed garden because Christian tradition associated the private green space with purity, prayer, and paradise, the latter of which awaits Christians in heaven.

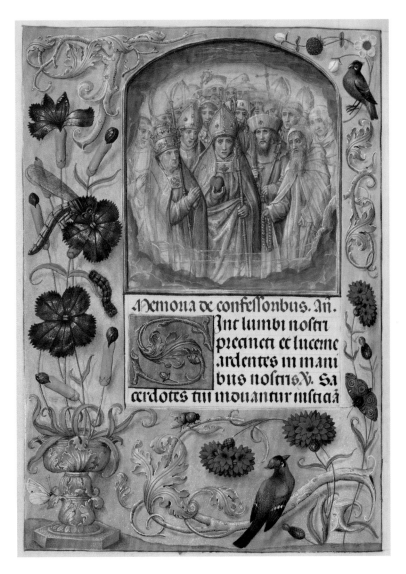

**Confessor Saints**

Master of James IV of Scotland
Spinola Hours
Bruges and Ghent, ca. 1510–20
Ms. Ludwig IX 18, fol. 262v

**Saint Sebastian**

Workshop of the Master of the
First Prayer Book of Maximilian
Spinola Hours
Bruges and Ghent, ca. 1510–20
Ms. Ludwig IX 18, fol. 254v

The vibrant flowers painted in the border of this image complement the brilliant gold background. Red carnations growing from a garden pot attract the attention of a caterpillar and dragonfly on the left of the page, while blue cornflowers grow from the ground and a flowering strawberry branch occupies the right side. Similar borders can be found throughout the manuscript, emphasizing the importance of garden flowers in the decorative design. In the miniature, Saint Augustine, holding his attribute of a heart, is in the foreground of the group of Confessor Saints, known for their deep faith in God.

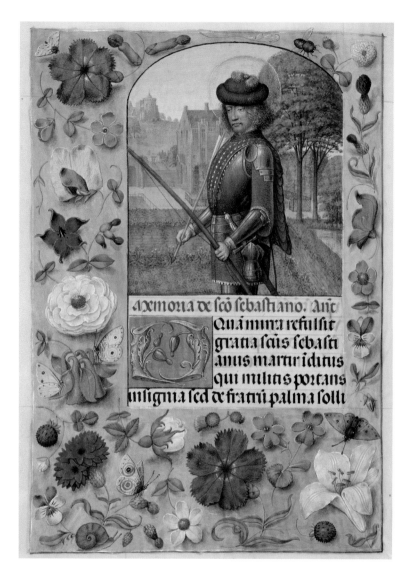

S aint Sebastian, the third-century Roman soldier and Christian martyr, stands dressed as a medieval knight in a garden connected to a large estate. In the midground behind the saint, a small fenced garden appears surrounded on two sides by trellised archways, which would have provided a shady walkway. Stone pathways define the outline of parterres planted with herbs and other small flowers. Typical of Flemish books of hours in the late fifteenth and early sixteenth centuries, the borders of this manuscript contain a rich array of flowers, including pinks, forget-me-nots, sweet pea, borage, white roses, columbines, cornflowers, flowering strawberries, violets, thistles, a lily, and monkshood.

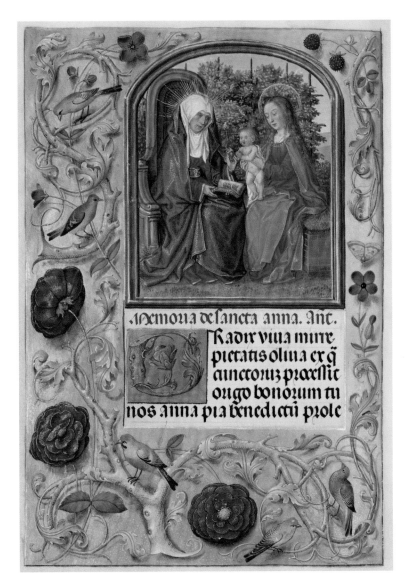

**The Virgin and Child
with Saint Anne**

Master of James IV of Scotland
Spinola Hours
Bruges and Ghent, ca. 1510–20
Ms. Ludwig IX 18, fol. 263v

The Virgin and Christ child sit on a grass bench before Saint Anne, enthroned and holding an open book in one hand while offering Christ an apple with the other. Behind the group is a trellis covered with white and red roses. The margins contain similar red roses, as well as strawberries and blue forget-me-nots. Each of these fruits and flowers symbolizes Christ's Passion.

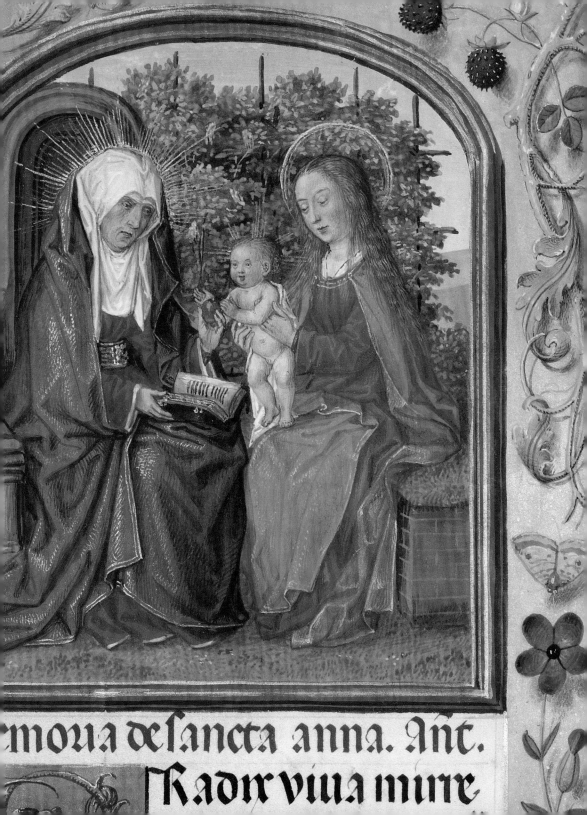

memoria de sancta anna. Ant.

Radix vitta mirtr

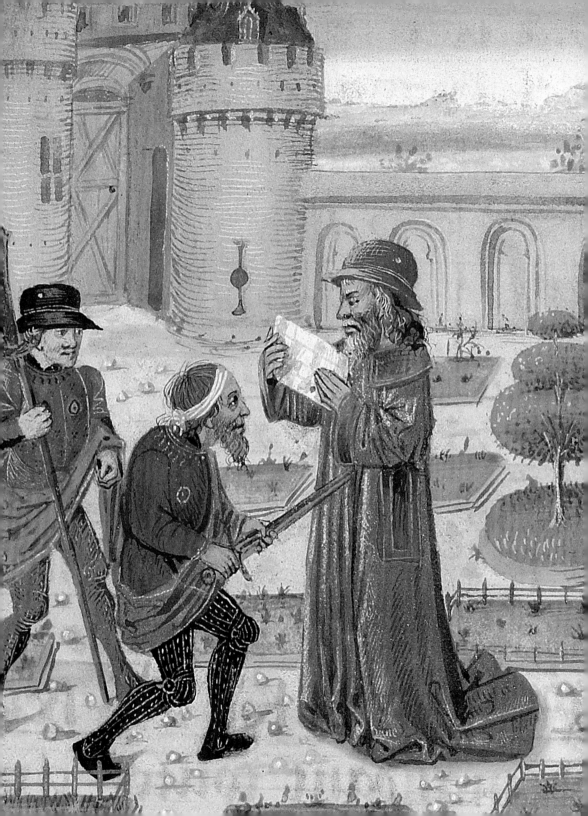

# Villas, Châteaux, and Courtly Spaces

"The manor houses of this region have ...
grand gardens that seem to have been planted by hand,
which were entirely for the delight of kings
and lieutenants."

QUINTUS CURTIUS RUFUS, *Book of the Deeds of Alexander the Great*

WHAT IS AN ITALIAN VILLA or French château without a garden? In the Renaissance, gardens complemented the architectural harmony of courtly estates through plantings along a central axis and beds of herbs and flowers arranged in geometric patterns. The combination of sculptures, fountains, and topiaries in gardens not only communicated the patron's control over nature but also expressed the Renaissance ideal that art and nature are in a constant back-and-forth duel of imitating each other. In manuscripts, a courtly garden could serve as a backdrop that conveyed a ruler's status or as a stage for activities both reputable and scandalous.

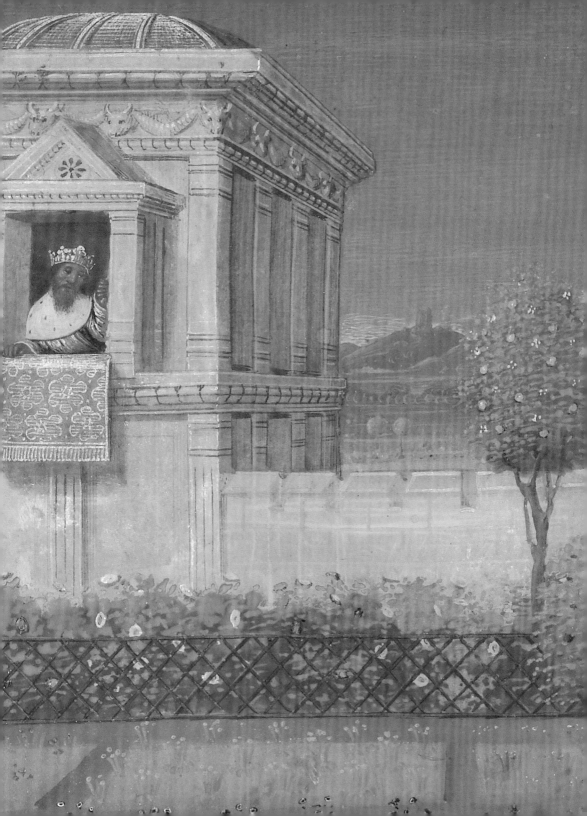

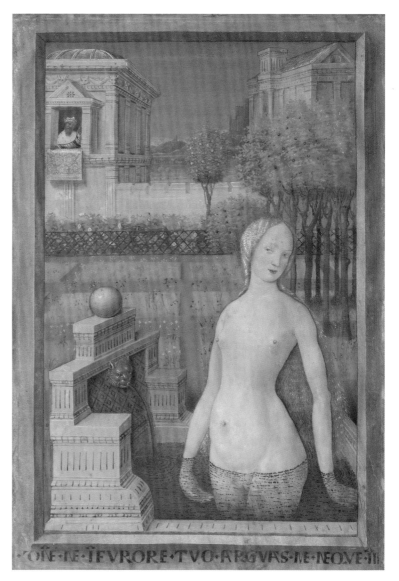

·OÑE·NE·ÎFVRORE·TVO·ARGVAS·ME·NEQVE·ÎÍ·

**Bathsheba Bathing**

Jean Bourdichon
Leaf from the Hours of Louis XII
Tours, 1498–99
Ms. 79, recto

Bathing in a garden fountain, Bathsheba, with her sensuous nude figure, seduces not only King David at the palace window but likely also the patron of the manuscript that contained this leaf, King Louis XII of France (r. 1498–1515). The biblical story that inspired this image does not mention a garden, but artists often placed Bathsheba in one because a garden traditionally represented female virtue. In most instances, David secretly spies on Bathsheba in the nude, but here she seems to be aware of her observer.

Louis XII employed Italian engineers to redesign gardens at his court, making them conform to the Renaissance principle of symmetry between palace and garden. In the illumination, the artist differentiates spaces for the planting of herbs, roses, and a citrus grove, all aspects one would expect to encounter in a royal garden.

## Female Figure

(possibly Venus, formerly
titled *Bathsheba*)
Giambologna
Florence, 1571–73
Marble; without plinth,
H: 115 cm (45¼ in.);
with plinth, H: 121.9 cm (48 in.)
82.SA.37

## Double Head

Attributed to Francesco Primaticcio
Fontainebleau, ca. 1543
Bronze, 38.5 × 35 × 20 cm
(15³⁄₁₆ × 13¾ × 7⅞ in.)
2011.45

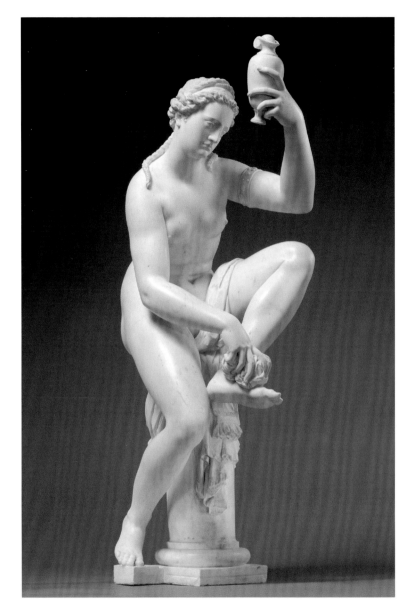

A part from flowers and plants, sculptures were an important component of
the Italian Renaissance garden. Following a precedent set by ancient Roman
garden owners, patrons in fifteenth- and sixteenth-century Italy (and later elsewhere
in Europe) began to adorn their gardens with sculptures primarily representing
mythological figures. Giambologna worked for the Medici family in Florence, and
his *Female Figure*, possibly Venus, once issued water out of the jar in her left hand,
thus forming a fountain possibly meant for a courtyard garden. Like the Medici,

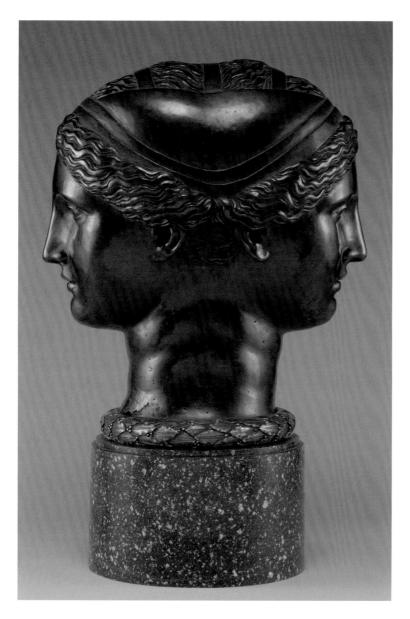

King Francis I of France (r. 1515–47) adorned his palace and garden at Fontainebleau with sculpture. One of the many Italian artists in residence at Fontainebleau was Primaticcio, whose *Double Head* was documented as early as the mid-seventeenth century as being displayed above the entrance to Fontainebleau's garden. Later, in the eighteenth century, the bronze sculpture graced the entrance to a garden at King Louis XIV's (r. 1661–1715) palace of Versailles.

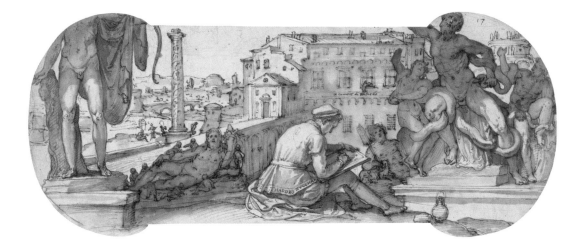

**Taddeo in the Belvedere Court
in the Vatican Drawing the Laocoön**

Federico Zuccaro
Italy, ca. 1595
Pen and brown ink,
brush with brown wash,
over black chalk and
touches of red chalk on paper,
17.5 × 42.5 cm (6⅞ × 16¾ in.)
99.GA.6.17

The Belvedere Court in the Vatican was referred to as a *viridarium*, or pleasure garden, and it was one of the sites most frequently visited by dignitaries, courtiers, and clergy in sixteenth-century Rome. The organizing principle of this papal garden centered on the display of the greatest sculptures of the ancient city, many of which had been recently unearthed, in a setting that evoked the gardens of the Caesars. Visitors often wrote about the fragrant citrus trees. In the drawing, which does not show these trees, Taddeo Zuccaro sketches the famous *Laocoön* sculpture group, showing a father and his two sons being strangled by a serpent, a punishment inflicted by Apollo for their having warned the Trojans not to accept the wooden horse left by the Greeks. Behind Zuccaro is the famous *Apollo Belvedere*, named after the site, and nearby are personifications of the river gods Tiber and Nile. Thus, Federico Zuccaro's drawing demonstrates the importance of gardens as sites for aspiring artists to see and draw from ancient sculptures.

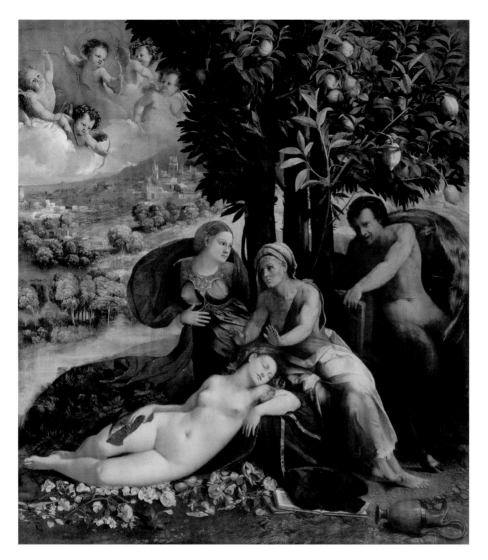

**Mythological Scene**

Dosso Dossi
Ferrara, ca. 1524
Oil on canvas,
163.8 × 145.4 cm
(64½ × 57¼ in.)
83.PA.15

Citrus trees, like those beautifully rendered in Dosso Dossi's painting of a mythological scene, were among the most prized plants in a Renaissance garden. In winter months, the potted trees were housed in an indoor room or building akin to a greenhouse, known as a *limonaia* (Italian) or *orangerie* (French). The Este court of Duke Alfonso I, for whom this painting may have been commissioned, featured numerous gardens, including one in the countryside around Ferrara filled with citrus trees. Here, strewn beneath the sleeping female nude, are roses, irises, a lily, a columbine, citrus blossoms, and borage, each of which Dosso painted with precision.

**March: Gardening;**
**Zodiacal Sign of Aries**

Workshop of the Master of James IV
of Scotland
Spinola Hours, use of Rome
Bruges and Ghent, ca. 1510–20
Ms. Ludwig IX 18, fol. 2v

Calendars containing important feast days of the church year were located at the beginning of books of hours, and they often included scenes of the month's main labor activity. Here, for March, an aristocratic couple enjoys a garden, while two gardeners busily till the soil in preparation for the spring season. The history of gardens is surely one of class distinction, from the lush and expansive gardens of the nobility to the modest kitchen gardens of the working class, which may have consisted of only a few potted herbs. A roundel in the border shows the Annunciation, an important Christian feast celebrated on March 25. The scene pairs nicely with the act of gardening, since Mary is often shown in or near a garden as a symbol of her virginity.

Marcius ha
bet dies xxxi
Luna xxx
iij  d  Albini epi
      e  lucii episco
xi   f  Marini mr
      g  Adriani mr
xix  A  Eusebij z foce
viij b  victoris mr
      c  ppetue z felic
xvi  d  Cypriani epi
v     e  xl martyrii
      f  Celidonij mr
xiij g  Gorgonij mr
ij   A  Gregorij ppe
      b  Innocecij pp
x     c  Scor lxv mr

      d  Longini mr
vuij e  hylarii epi
vij   f  Gertrudis v
      g  Alexandri c
xv   A  Iohis heremite
iiij b  Gutberti epi
      c  Benedci abb
xij  d  pauli episco.
j     e  victoriani mr
      f  pigmenij psb.
ix   g  Annuciaa ma.
      A  liudgeri epi
xvij b  Resurrecto do
vj    c  Arnoldi epi
      d  Gregorij epi
xiiij e  Dominia ht
iij   f  Balbine vg

ARIES

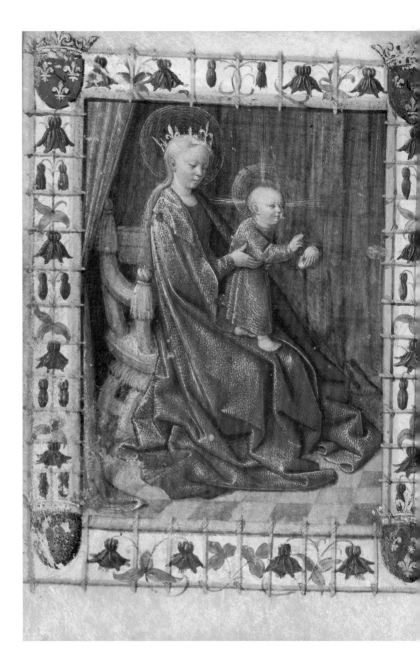

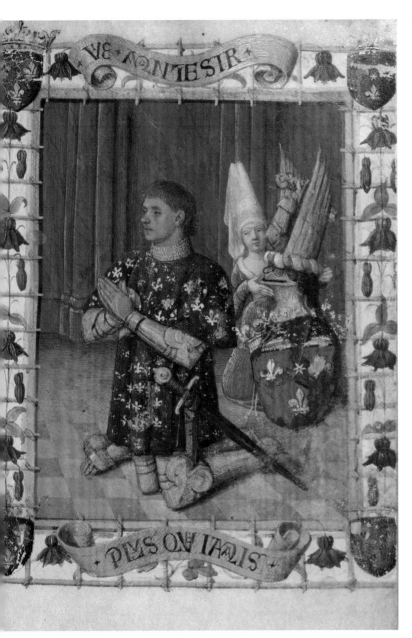

### The Virgin and Child Enthroned; Simon de Varie Kneeling in Prayer

Jean Fouquet
Hours of Simon de Varie
Paris or Tours, 1455
Ms. 7, fols. 1v–2

Jean Fouquet framed this portrait of Simon de Varie, dressed as a knight and kneeling before the Virgin Mary and Christ child, with a trellis strewn with columbines. This flower is often associated with mourning or loss, but it could also symbolize fidelity and fertility, both important virtues for a Renaissance nobleman and knight like Simon de Varie.

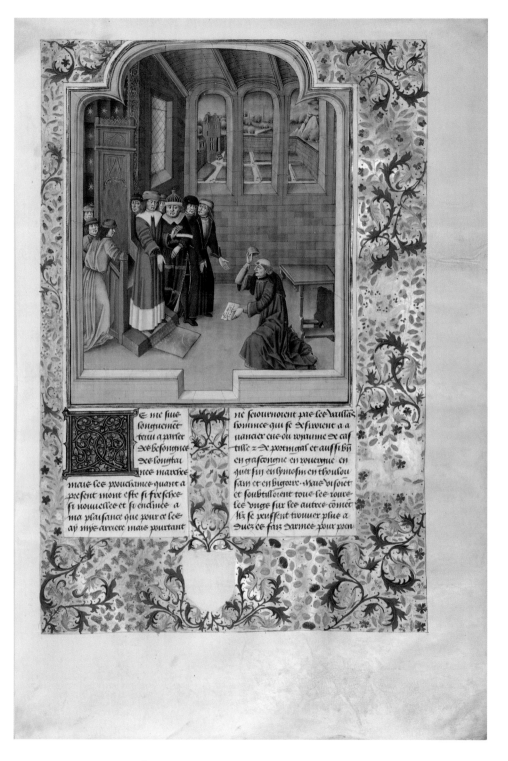

E me sint
longuemēt
tenu a pʒser
Des besongnes
Des longtai-
nes marches
mais les prouchanes quant a
pʒsent mont este si freschee
si nouuellee et si endinee a
ma plaisance que ʒour et lee
ay mye arriere mais ʒourtant

ne seiournoient pas lee uillās
sommee qui se Desiuoient a a-
uanchier eue ou wyaume De cas-
tille ʒ De ʒortingal et auffi bn
en gascongne en rouergue en
quer sin en lymosin en thoulou-
sam et en bigorie mais vi soiēt
et soubtilloient toue lee routee
lee vnge sur lee autree comet
ilz se ʒeussent trouuer plus a
Suez ee faiz Darmee ʒour ʒen

**Froissart Kneeling before Gaston
Phébus, Count of Foix**

Master of the Soane Josephus
Jean Froissart, *Chronicles*
Bruges, ca. 1480–83
Ms. Ludwig XIII 7, fol. 9

This image opens a section of Jean Froissart's *Chronicles* devoted to describing the battles between France, England, and surrounding regions during the Hundred Years' War (1337–1453). Froissart kneels to present a letter of introduction to Gaston Phébus, Count of Foix (in southwestern France), to whose court Froissart traveled to learn news of the wars in that region. Beyond the window is a typical Renaissance garden arranged into geometric plantings that suggest the opulence of Gaston's court. Elsewhere in the text, Froissart describes looking out the window to view gardens like the one in this illumination. The intimate size of the garden and its connection to the court's private apartments recall the "secret garden," a name that refers not to a hidden space but to a garden designated for personal use or as a showcase for worthy guests.

## Initial *H*: David in Prayer

Workshop of Gerard Horenbout
Book of Hours
Ghent, ca. 1500
Ms. Ludwig IX 17, fol. 71

In this initial *H*, the biblical figure of King David kneels in prayer inside a fenced garden with a church-like structure and residence beyond. A psaltery, a type of harp, lies on the ground next to his scepter and regal headdress. In the Renaissance, gardens were considered ideal sites in which a ruler could revive his spirit or meditate. The Italian humanist Marsilio Ficino (1433–1499) advocated the viewing of greenery or listening to music by stringed instruments as a way to counter a melancholy temperament. The German text on the page begins with the words to the first of seven psalms of repentance ascribed to David: "Lord, do not rebuke me in your anger." Thus a quiet, lyrical garden is the ideal setting for communicating to the viewer David's melancholy and penitence.

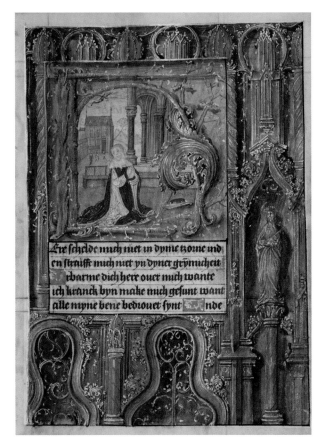

## The Death of Parmenion

Master of the *Jardin de vertueuse consolation*
Quintus Curtius Rufus,
*Book of the Deeds of Alexander the Great*
Written in Lille, illuminated in Bruges, ca. 1470–75
Ms. Ludwig XV 8, fol. 154

Murder is not typically a courtly activity associated with gardens. In this image, however, an agent of Alexander the Great (356–323 B.C.) stabs the traitorous general Parmenion to death in a walled garden with low plant beds and topiary. The clothing, architecture, and landscape settings featured throughout the manuscript are reminiscent of the fifteenth-century Burgundian court rather than the fourth-century B.C. world of Alexander, helping Renaissance viewers to make a connection between the great leader's experiences and their own. As the text states, the gardens in the distant East were grand spaces designed for the enjoyment of kings and generals. It is ironic that Parmenion should die in such an idyllic place.

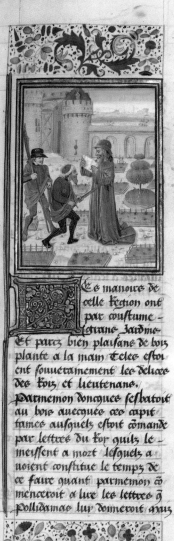

Es manoirs de
celle region ont
par coustume
lestrans Jardins
Et parez bien plaisans de boiz
plante a la main Et les estoi
ent souuerainement les delices
des boiz et lieutenans.
Parmenon donc ques sesbatoit
au bois auecques ces capit
taines ausquelz estoit commande
par lettres du roy quilz le
meissent a mort lesquelz a
uoient constitue le temps de
ce faire quant parmenon co
menceroit a lire les lettres q̃
pollidamas luy donneroit auc

pollidamas venant de lomatz
Ainsi quil fut veu de pmemon
Il courut a lembrachier a chiere
preferant samblant de grant
Joye Et depuis quilz eurent
salue lun lautre pollidamas
luy bailla les lettres escriptes
du Roy. Parmemon rompant
la chancelle demandoit que le
Roy faisoit Aguoy pollidamas
luy respondit que ce sauroit
il par ces lettres Et apres ce
que parmemon les eut leutes
Il dist le Roy sapreste dentrer
es Oracostes Vaillat
homme et Jamais non cessant
naue seroit temps de espargnd
sa personne apres auoir acqui
esme tant de gloire Puis lisoit
les autres lettres escriptes ou
nom de philotes estant assez
Joieux comme il se pouoit bien
noter a son samblant. Adont
Adont Cleander le trespercha
de son glaue au coste puis le
ferr sur le col. Les autres
aussi le percherent Ja a demy
mort, Les sergans qui assistoi
ent alentree du boiz cognoiss
sa mort dont len ygnoroit la
cause retournerent en lost Et
par ces messages sedicieux se

### A View of a Garden Float Extended

Festival prints relating to the wedding
of Grand Duke Ferdinando I
de' Medici to the French princess
Christine of Lorraine
Florence, ca. 1589–92
2000.PR.48, print 10

As part of the festivities surrounding the wedding of Grand Duke Ferdinando I in 1589, the duke's nephew Virginio organized a series of street floats to entertain visitors in the courtyard of the ducal palace in Florence. Here, Virginio, dressed as Mars, the god of war, sits enthroned on a float designed like a small garden, which is itself behind another float representing a magician seated atop a dragon. Surrounding the floats are twenty sections of fences, trellises, topiary, statuary, and live birds. Within the paradise-like space, Virginio and his companions enact a mock battle for love, an appropriate theme for a wedding. Those witnessing the event would no doubt have been impressed by the float and by the lavish Medici palace garden nearby, which remains famous today as the Boboli Gardens.

### Stage Design, Intermedio 2

Festival prints relating to the wedding
of Grand Duke Ferdinando I
de' Medici to the French princess
Christine of Lorraine
Florence, ca. 1589–92
2000.PR.48, print 11

Another spectacle at Ferdinando's wedding was a stage design featuring grottoes, pergola arches, mythological figures playing musical instruments, and Mount Parnassus—the sacred home of the Muses and of Apollo, who dominates the center of the composition.

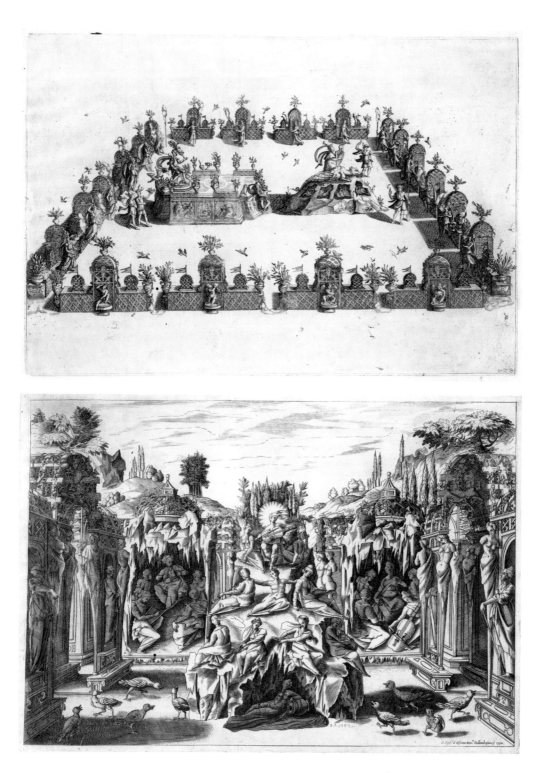

## Pentecost

Georges Trubert
Book of Hours
France, ca. 1480–90
Ms. 48, fol. 48

The garden of a courtly couple has overgrown beyond a crenellated wall, filling the pages of this book of hours and forming a colorful and lively frame around the scene of Pentecost (when the Holy Spirit in the form of a dove descended on the apostles, enabling them to speak in foreign languages in order to spread Christianity). The man stands near a bunch of flowers called speedwell, while the woman grasps a daisy in her right hand. Counterclockwise from lower right around the margin are red roses, periwinkles, white and purple phlox, and red currants.

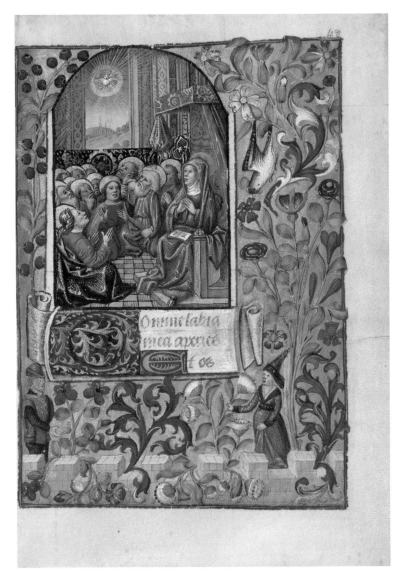

## A Patron Presented to the Virgin and Child

Workshop of the Boucicaut Master
Paris, ca. 1415–20
Ms. 22, fol. 137

A delicate border of garden flowers fills the page around a scene of an angel presenting a young woman to the Virgin and Christ child. The daisies woven into intricate posies in the upper, right, and lower margins suggest that the woman may have been named Margaret, since the word for daisy in French is *marguerite* and daisies feature prominently throughout the manuscript.

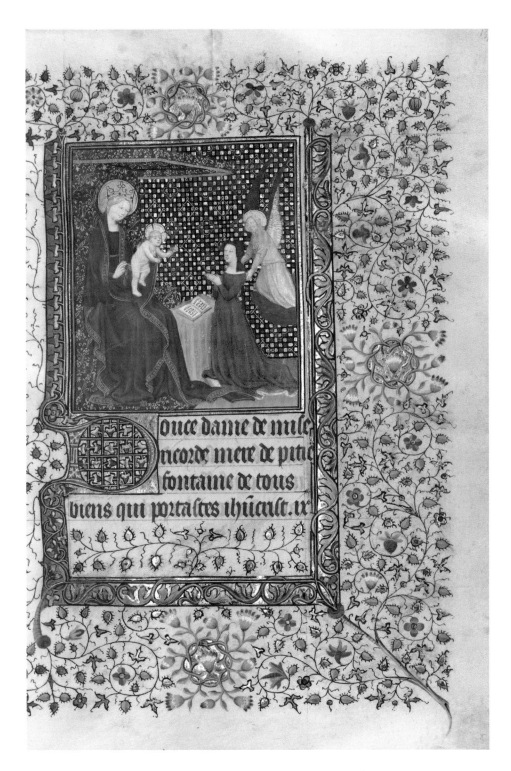

ouce dame de mise
ricorde mere de pitie
fontaine de tous
biens qui portastes ihucrist. ix

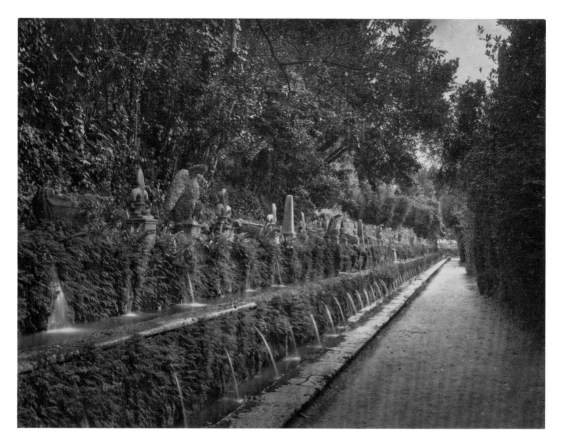

**Villa d'Este,
Gallery of Fountains**

James Anderson
Rome, ca. 1855–77
Albumen silver print,
19.5 × 25.5 cm
(7¹¹/₁₆ × 10¹/₁₆ in.)
84.XP.709.468

S et within a hillside landscape rich in Roman imperial villas and monuments, the
Villa d'Este in Tivoli, a city just under twenty miles northeast of Rome, was the
majestic residence of Cardinal Ippolito d'Este (1479–1520). Fountains and water-
works, like the Gallery of the Hundred Fountains, are the main attractions of the Villa
d'Este. Atop the rows of shooting water are sculpted emblems of the Este family:
boats, fleurs-de-lis, eagles, and obelisks. The spectacular water features in the garden
were designed by Pirro Ligorio (ca. 1510–1583).

James Anderson (1813–1877) was a British photographer who spent consider-
able time in Rome documenting the city's many architectural wonders, including the
magnificent nearby estate of the Villa d'Este. The strong diagonal that Anderson
used in the photograph gives a sense of the Gallery of the Hundred Fountains' length,
a feature that still inspires awe today.

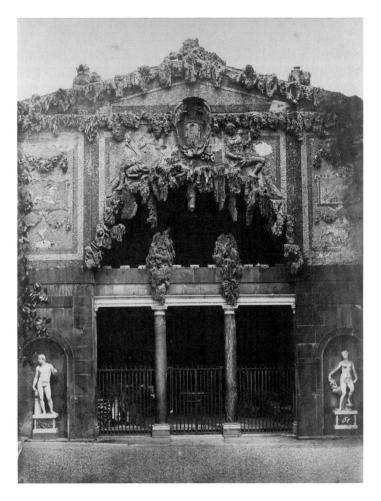

**Cave at the Boboli Gardens**

Fratelli Alinari
Florence, 1850s
Albumen silver print,
34.5 × 26.4 cm
(13⁹⁄₁₆ × 10⅜ in.)
84.XM.508.9

The *grotta*, or cave, designed by Bernardo Buontalenti (1536–1608) between 1583 and 1593 is one of the most recognizable points of interest in the famous Boboli Gardens at the Palazzo Pitti in Florence. Leon Battista Alberti (1404–1472) wrote in his treatise on architecture that "the ancients used to dress the walls of their grottoes and caverns with all manner of rough work, with little chips of pumice," an approach followed by Buontalenti, who also created a polychrome sculptural program showing bucolic figures from ancient Roman myth. Giovanni del Tadda designed the equally artificial facade, which features the Medici emblem of the six *palle*, or balls, above the central portion over the entrance. On either side of the entrance are sculptures by Baccio Bandinelli showing the sun god of music, Apollo (left), and the goddess of agriculture, Ceres (right).

The photography firm Fratelli Alinari was founded in Florence in 1852 by brothers Leopoldo, Giuseppe, and Romualdo. The three traveled extensively and photographed people, works of art, and monuments. The soft hues of the albumen silver print above temper the rough features of the cave's facade, while the darkness in the center of the composition creates an ominous feeling often associated with the strange, damp, and poorly lit interiors of these subterranean places.

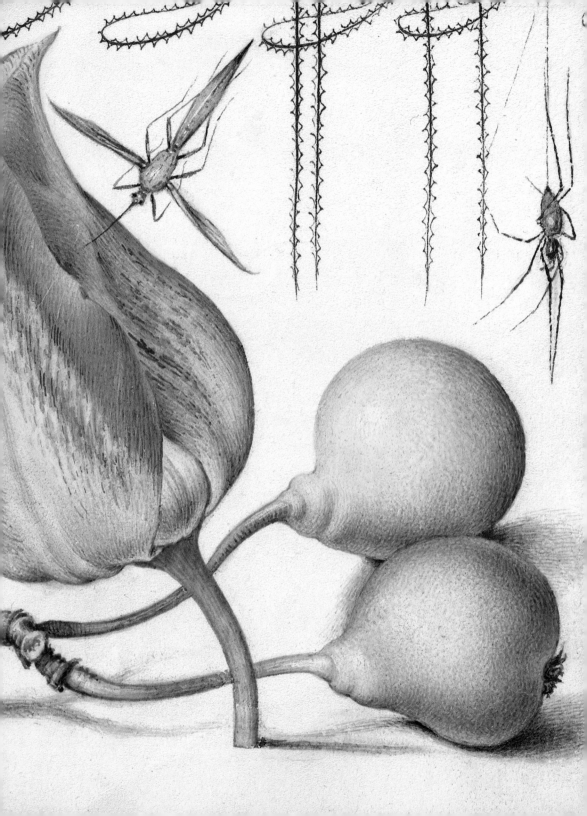

# Illuminating the Natural World

## Model Book of Calligraphy

In the *Model Book of Calligraphy*, the illustrations rival the script in beauty and complexity. Holy Roman Emperor Ferdinand I (r. 1558–64) commissioned Georg Bocskay to demonstrate a vast range of writing styles. About thirty years later, Emperor Rudolph II (r. 1576–1612), Ferdinand's grandson, commissioned Joris Hoefnagel to illuminate Bocskay's model book.

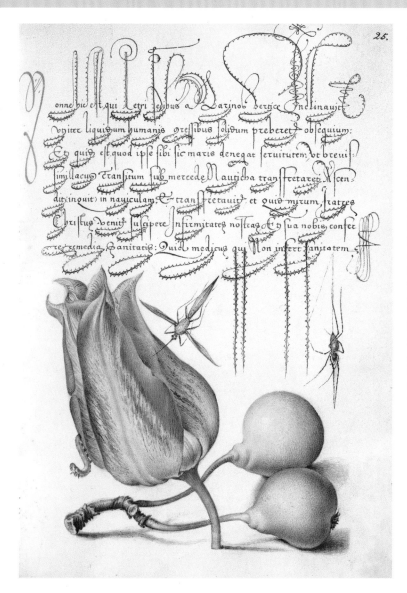

**Insect, Tulip, Caterpillar, Spider, Pear**

Joris Hoefnagel
*Model Book of Calligraphy*
Vienna, written by
Georg Bocskay, 1561–62,
illuminated 1591–96
Ms. 20, fol. 25

Painted with spellbinding precision, the pink-and-yellow-striped tulip shown here is among seven of varying colors painted by Joris Hoefnagel. Rudolf cultivated botanical rarities, like the tulip, in gardens throughout his empire, and Hoefnagel's highly accurate illuminations preserve a floral record of species from as far away as modern-day Turkey and Peru. Over the next half century, tulips were considered a valuable commodity. Avid collectors could even buy shares in tulip stock, which often resulted in financial ruin when the market plummeted.

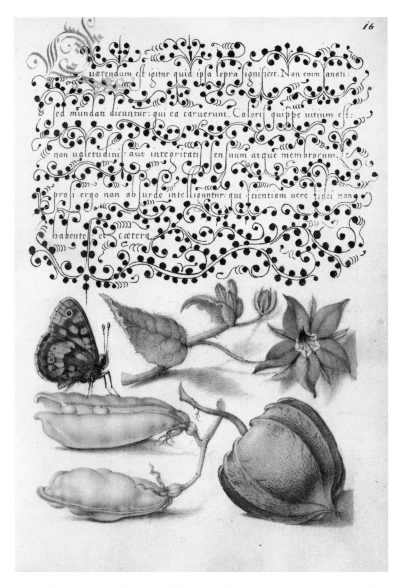

Illuminating
the Natural World

**Speckled Wood, Talewort,
Garden Pea, and Lantern Plant**

Joris Hoefnagel
*Model Book of Calligraphy*
Vienna, written by
Georg Bocskay, 1561–62,
illuminated 1591–96
Ms. 20, fol. 16

H oefnagel appears to have carefully selected the plants on this page to mirror the
shape and rhythm of Bocskay's calligraphy. The rounded peas in the pod, for
example, echo the dark dot flourishes surrounding the text, and the shape and color of
the lantern plant mirror the shape of the gold initial *Q* on the first line. The blue
talewort, an annual flower, adds a color that complements the nearby perennial, the
orange lantern plant.

**Sweet Violet and Spanish Broom**

Joris Hoefnagel
*Model Book of Calligraphy*
Vienna, written by
Georg Bocskay, 1561–62,
illuminated 1591–96
Ms. 20, fol. 20

Hoefnagel ingeniously painted the stem of a sweet violet to appear as if it is passing through the parchment and weaving between the descending lines of the letters *q* and *f*. This technique of trompe l'oeil (fooling the eye) demonstrates Hoefnagel's creativity and ability to adapt his naturalistic illuminations to the space available on a page.

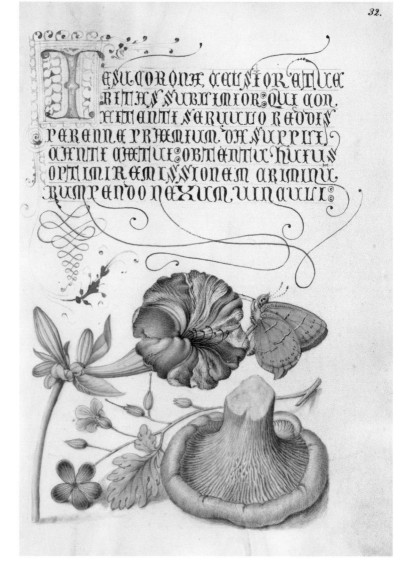

32.

Four-o'Clock, Brown Hairstreak,
Herb Robert, and Chanterelle

Joris Hoefnagel
*Model Book of Calligraphy*
Vienna, written by
Georg Bocskay, 1561–62,
illuminated 1591–96
Ms. 20, fol. 32

Known as the marvel of Peru, the four-o'clock flower is said to have been exported to Europe from South America beginning as early as 1540. The flower can change colors throughout the day or can bloom with multiple colors simultaneously, as seen in Hoefnagel's carefully rendered variation of pink and yellow. This unique plant would have no doubt been a rare gem in one of Rudolf's gardens at the time, and in the manuscript it is complemented by a European flower called Herb Robert.

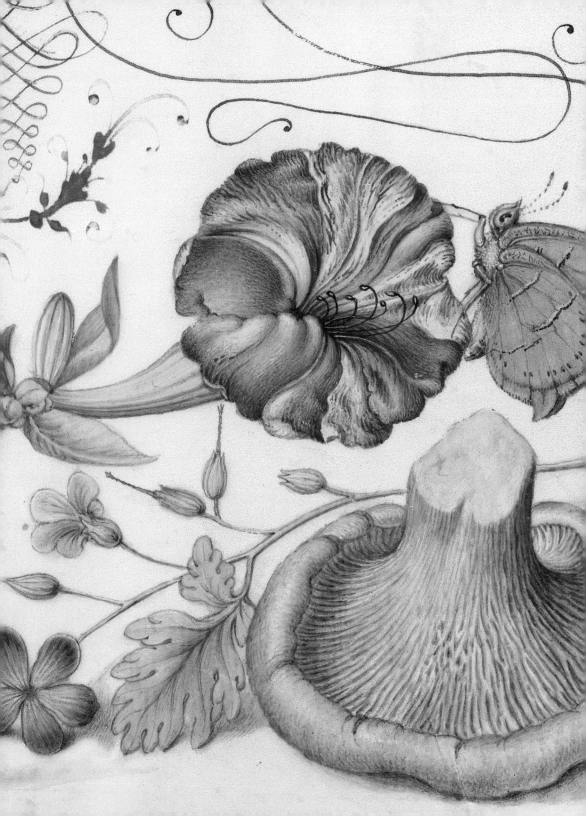

# Suggestions for Further Reading

*An Abecedarium: Illuminated Alphabets from the Court of Emperor Rudolf II*. Los Angeles: Getty Publications, 1997.

Antoine, Elisabeth. *Sur la terre comme au ciel: Jardins d'occident à la fin du Môyen Age*. Exh. cat. Paris, Musée national du Môyen Age, thermes de Cluny, 2002. Paris: Éditions de la Réunion des musées nationaux, 2002.

Beneš, Mirka, and Diane Harris, eds. *Villas and Gardens in Early Modern Italy and France*. Cambridge: Cambridge University Press, 2001.

Cardini, Franco, and Massimo Miglio. *Nostalgia del paradiso: Il giardino medievale*. Rome-Bari: Gius. Laterza & Figli S.p.A., 2002.

Fisher, Celia. *Flowers of the Renaissance*. Los Angeles: Getty Publications, 2011.

————. *The Medieval Flower Book*. London: British Library, 2007.

Gousset, Marie-Thérèse. *Jardins médiévaux en France*. Rennes: Éditions Ouest-France, 2010.

Hendrix, Lee, and Thea Vignau-Wilberg. *The Art of the Pen: Calligraphy from the Court of Emperor Rudolf II*. Los Angeles: Getty Publications, 2003.

Impelluso, Lucia. *Gardens in Art*. Los Angeles: Getty Publications, 2007.

Lazzaro, Claudia. *The Italian Renaissance Garden: From the Conventions of Planting, Design, and Ornament to the Grand Gardens of Sixteenth-Century Central Italy*. New Haven: Yale University Press, 1990.

*Nature Illuminated: Flora and Fauna from the Court of Emperor Rudolf II*. Los Angeles: Getty Publications, 1997.

Stokstad, Marilyn, and Jerry Stannard. *Gardens of the Middle Ages*. Exh. cat. Lawrence, Kans., Spencer Museum of Art, University of Kansas, and Washington, D.C., Dumbarton Oaks, 1983. Lawrence: University of Kansas Printing Services, 1983.

Vercelloni, Matteo, and Virgilio Vercelloni. *Inventing the Garden*. Los Angeles and Milan: J. Paul Getty Trust and Editoriale Jaca Book S.p.A., 2010.

Woodbridge, Kenneth. *Princely Gardens: The Origins and Development of the French Formal Style*. London: Thames and Hudson, 1986.

## ONLINE RESOURCES

Catena Digital Archive of Historic Gardens and Landscapes, Bard Graduate Center. http://catena.bgc.bard.edu.

Cloisters Museum and Gardens, Metropolitan Museum of Art. *The Medieval Garden Enclosed* (blog). http://blog.metmuseum.org/cloistersgardens.

Dumbarton Oaks Research Library and Collection. *Garden Blog* (blog). http://www.doaks.org/gardens/blog-info.

# Index of Names

A Woman Kneeling in a Garden;
Zodiacal Sign of Taurus

Katherine Hours
Tours, ca. 1480–85
Ms. 6, fol. 2v

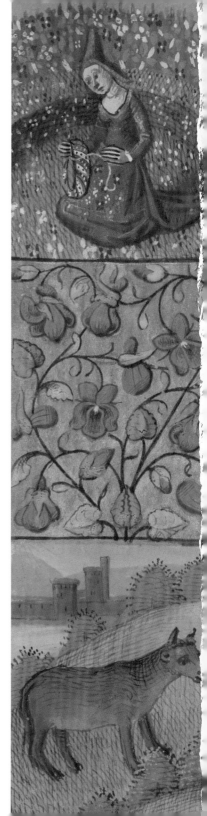

## ACKNOWLEDGMENTS

I offer special thanks to my cohorts and professors at Syracuse University for introducing me to Renaissance gardens. Many at the Getty Museum contributed ideas, including Michael DeHart, Elizabeth Nicholson, and curators Thomas Kren, Scott Allan, Antonia Boström, David Brafman, Julian Brooks, Lee Hendrix, Arpi Kovacs, Marcia Reed, Stephanie Schrader, and Anne Woollett. From the Manuscripts Department, Kristen Collins, Erene Morcos, Christine Sciacca, Melanie Sympson, and Nancy Turner provided much-needed support throughout this project.

Thank you to Getty Publications, especially Jeffrey Cohen, Amita Molloy, Elizabeth Nicholson, and independent editors Ellen Hirzy and Karen Stough.

To my friend Christine Spier and mentors Michael Zakian and Cynthia Colburn I owe my love of art history. I am especially grateful to Elizabeth Morrison for the opportunity to write this book, for her guidance in curating an exhibition of the same title, and for her constant encouragement and friendship. I dedicate this book to my parents, Ken and Rose Keene, to Sam and Kendra, and to Mark Botieff, without whom life's verdant garden would become an unbearable desert.

## DETAILS

p. iii: Master of the Dresden Prayer Book or Workshop, *The Virgin and Child Enthroned* (see p. 32)
p. iv–v: Master of James IV of Scotland, *The Annunciation* (see p. 43)
p. vi: Lieven van Lathem, *Noli me tangere* (see p. 40)
p. viii: Workshop of the Master of the First Prayer Book of Maximilian, *Saint Sebastian* (see p. 45)
p. 8: Attributed to Illustratore (Andrea da Bologna?), *Harvest Scene; Initial* U: *A Figure* (see p. 11)
p. 22: Simon Bening, *Scenes from Creation* (see p. 24)
p. 48: Master of the *Jardin de vertueuse consolation*, *The Death of Parmenion* (see p. 63)

## SOURCES FOR QUOTATIONS

p. ii: Giovanni Pontano, *I trattati delle virtù sociali: De liberali tate, De beneficentia, De magnificentia, De splendore, De conviventia*, edited by Francesco Tateo (Rome: 1965), 277. Quotation translated by Bryan C. Keene.
p. 9: Guillaume de Lorris and Jean de Meun, *The Romance of the Rose*, translated by Charles Dahlberg (Princeton, 1995), p. 39, ll. 631–37.
p. 23: Bible (New American Standard Reference Version), Genesis 2:8–9.
p. 49: Quintus Curtius Rufus, *Book of the Deeds of Alexander the Great* (ca. 1470–75). Quotation translated by Bryan C. Keene.